IMAGES
of America
CINCINNATI'S MT. LOOKOUT NEIGHBORHOOD

ON THE COVER: In this photograph, taken around 1916, a group of men and women has boarded a free bus in front of Abner Curtis's drugstore at the corner of Delta Avenue and Linwood Avenue, where the United Dairy Farmers (UDF) parking lot is located today. La Preferencia was a popular maker of cigars at the time. (Courtesy of the General Photographic Collection–Suburbs [SC#59], Cincinnati Museum Center.)

IMAGES
of America

CINCINNATI'S MT. LOOKOUT NEIGHBORHOOD

Jason Fitzhugh

Copyright © 2024 by Jason Fitzhugh
ISBN 9781-4671-6168-8

Published by Arcadia Publishing
Charleston, South Carolina

Printed in the United States of America

Library of Congress Control Number: 2024932528

For all general information, please contact Arcadia Publishing:
Telephone 843-853-2070
Fax 843-853-0044
E-mail sales@arcadiapublishing.com

Visit us on the Internet at www.arcadiapublishing.com

This book is dedicated to my parents, Jack and Sharyn. I love you both.

CONTENTS

Acknowledgments		6
Introduction		7
1.	Getting to Mt. Lookout	9
2.	Early Growth and Development	17
3.	The Observatory	33
4.	Ault Park	39
5.	Alms Park	51
6.	Tragedy Strikes	57
7.	The Heart of the Town	65
8.	Schools and Churches	87
9.	Celebrations and Community	103

ACKNOWLEDGMENTS

Writing this book, while a longtime ambition of mine, has been a time-consuming project, and I could not have done it without the help of so many individuals and agencies. First, I would like to thank the Cincinnati & Hamilton County Public Library, Christopher Harter at the Archives and Rare Books Library at the University of Cincinnati, and the Kenton County Library in Covington for their help. Next, I owe a great deal of gratitude to Arabeth Balasko, curator of photographs, print, and media at the Cincinnati Museum Center; Mickey deVise, reference librarian at the Cincinnati History Library and Archives; and Vicki Newell at Cincinnati Parks Library and Archives, Bettman Center. I would like to express my appreciation for the assistance that I received from the Mt. Lookout Community Council, including Rob Pasquinucci, Kim Rice, and Alexis Morrisroe. Thank you to Mandy Askins, assistant collections manager at the Cincinnati Observatory; Phil Lind at the Greater Cincinnati Police Museum; Kim Reis from the *Cincinnati Enquirer* archives (USA Today/Imagn); Jeff Levine, president of the Ault Park Advisory Council; Pam Gruesser at Our Lord Christ the King Church; and Angela Cook Frazier and Tracy Mathews at Kilgour Elementary for your time and assistance. To my editor, Amy Jarvis, thank you for your guidance and communication.

Additionally, I am grateful to the many local residents who took the time to share their stories and search through their old photo albums to help me make this project a reality. It was a pleasure to meet with each of you.

Last but not least, thank you to my husband, Judd, for his total support and encouragement during this project.

INTRODUCTION

When I graduated from Bowling Green State University in 1997, I returned to my hometown of Cincinnati and searched newspaper ads for apartments to rent. I grew up in Reading (which is about 12 miles away), but I don't recall ever being in Mt. Lookout during my youth. When I found my first apartment (which was on the second floor of a 19th-century home that had been converted into a duplex), I immediately fell in love with this neighborhood. The grand homes, the beautifully manicured lawns, kids walking home from Kilgour Elementary—it was all like a scene from a movie. In fact, it makes sense why parts of the 1994 movie *Milk Money* were filmed here.

To walk or drive through Mt. Lookout Square is like stepping back in time. Mt. Lookout Tavern and Zip's Café were the original diners (established 1921 and 1926, respectively). The Mt. Lookout Theater, with its beautiful Art Deco design and architecture, has dominated the western side of the square since 1940. Geo. H. Rohde & Sons Funeral Home, built in 1920, looks like a mansion from days gone by. Interestingly, however, it never was a residential home. In fact, it was one of the first funeral homes in the city to be built for its purpose. Stereo ADV occupies what was one of the earliest residential homes in the square, built in 1907. Although no longer used as a residence, the sleeping porches in the rear seem to echo memories of people who once used them.

Mt. Lookout began as a small, rural village called Delta. Crawfish Creek flowed down Delta Avenue (back then it was called Crawfish Road) all the way to the Ohio River. In 1870, the village was annexed by the City of Cincinnati. Brothers John and Charles Kilgour invested heavily in real estate and transportation. John Kilgour purchased the Pines estate, which was situated exactly where Clark Montessori sits today—although Erie Avenue had not yet been built. The main driveway to the Pines extended from Observatory Avenue to the house. In 1872, the original Cincinnati Observatory in Mt. Adams was abandoned due to polluted skies near downtown. The new observatory was built at the end of Observatory Place, and subsequently, the name "Mt. Lookout" was born.

At this point, the Mt. Lookout "Dummy" was built. There was already a steam car service that ran from downtown to Delta Avenue. The Dummy line branched off at Delta Avenue, stretching north to what would become Mt. Lookout Square. The Kilgours provided financial support for the car service in order to achieve their goal: to sell off their real estate parcels. To say they were successful would be an understatement. By having access to Mt. Lookout via the Dummy, more people began to move from downtown to this new suburb that was slowly beginning to grow. Grand estates began to appear.

In the early 20th century, a series of events secured Mt. Lookout's success in drawing new residents. In 1905, the Grandin Road Bridge was erected, delivering a quick, direct route from East Walnut Hills to Mt. Lookout as it spanned high above Delta Avenue. Ault Park and Alms Park were established in 1911 and 1916, respectively. Alms Park is geographically located in Columbia-Tusculum; however, due to its close proximity and easy access for many Mt. Lookout residents, I believe it is important and worthwhile to include the development of Alms Park as another

pull factor that attracted people to this area. In fact, many early newspaper articles refer to Alms Park as belonging to Mt. Lookout. Additionally, the "grand opening" of Mt. Lookout Square in 1916 offered two local grocery stores and a pharmacy, and soon thereafter, the John Kilgour Public School opened in 1922. Prior to the new school being constructed, most Mt. Lookout children attended Hyde Park Public School. By 1911, the Hyde Park building was overcrowded, and thus a small colony school was built at Delta Avenue and Niles Street. Following the death of John Kilgour in 1914, his wife, Mary, generously donated land on Herschel Avenue for a proper elementary school to be built for the children of Mt. Lookout.

The first church to be constructed was the Mt. Lookout Methodist Episcopal Church in 1880, when the Mt. Lookout community was just 10 years old. It was, by today's standards, a rather small structure made of wood that stood on the corner of Grace Avenue and Observatory Avenue. The boundaries between Mt. Lookout and Hyde Park have always been a little blurry, and when this church was completed, Hyde Park was still a village called Mornington; it was later renamed Hyde Park and was annexed by the City of Cincinnati in 1903. Today, it is commonly agreed that Mt. Lookout's borders with Hyde Park run along Paxton Avenue to the west and, to the north, Griest Avenue (west of Delta Avenue) and Observatory Avenue (east of Delta Avenue). The Mt. Lookout Methodist Episcopal Church suffered some damage in 1917 from the destructive tornado that hit Grace Avenue, among several other streets. By 1927, a new church was raised on this very same corner; since then, it has been called the Hyde Park Community United Methodist Church. This was almost exactly when Our Lord Christ the King Catholic Church was built near Mt. Lookout Square. The original structure was modest, as was its four-room school. A new school, named after Eugenio Cardinal Pacelli, opened in 1937, and in 1957, the old church was replaced by one that towers (literally) above the square. Certainly, not everyone in Mt. Lookout is Catholic, but it is interesting to note that Our Lord Christ the King is the only church of any denomination within Mt. Lookout's boundaries. While the student population of Kilgour Elementary has always been greater, many families sent all their children (up to 10 in some cases) to Cardinal Pacelli Catholic School.

By the 1960s, Mt. Lookout seemed to have it all—good schools, shops, restaurants, a swim club and a theater, transportation, and walkability, in addition to such monumental attractions as the aforementioned Cincinnati Observatory, Ault Park, and Alms Park. And so it remains today. I would be remiss if I did not mention the significant role played by the Mt. Lookout Community Council over the years. Although its name has changed since it began in 1907 (first it was the Mt. Lookout Businessmen's Club and then Mt. Lookout Civic Club), the men and women of this organization have been integral to promoting and maintaining Mt. Lookout's camaraderie, safety, beauty, and economic prosperity.

History is always a work in progress. To say this book is the complete history of Mt. Lookout would not be true. Sadly, it is not uncommon that old photographs and records are discarded over time because they lose their value to subsequent generations. Those who have passed on no longer have a voice to share their stories. There is a proverb that says, "When an elder dies, a library burns to the ground." Take pictures. Ask questions. Write things down. The future will thank you for it.

One
GETTING TO MT. LOOKOUT

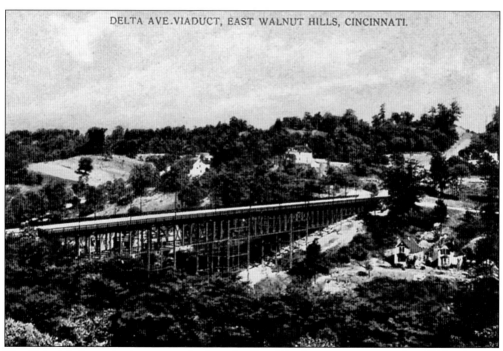

The Delta Viaduct, also known as the Grandin Road Bridge, was constructed in 1905. The cost then was $175,000. It provided an easy, direct route from Mt. Lookout to East Walnut Hills. Over the years, the bridge underwent several repairs, but in 1975, it was demolished, primarily due to structural safety concerns. (Courtesy of the Cincinnati & Hamilton County Public Library.)

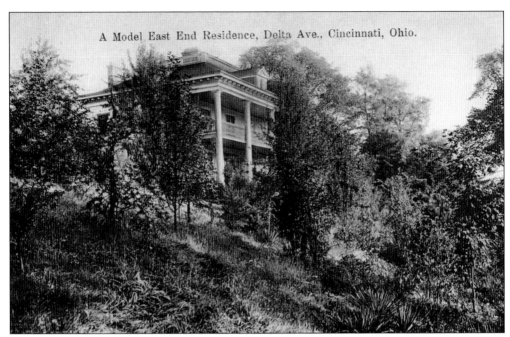

Delta Avenue has always been a major thoroughfare in Mt. Lookout. It runs from Erie Avenue south to Columbia Parkway and Eastern Avenue. This hillside plantation home sits majestically at 545 Delta Avenue. Built in 1894, the house recently underwent a full renovation. Ainee Hitzfield lived here in 1944 when her husband, 2nd Lt. Charles Hitzfield, was killed in Europe. (Courtesy of the Cincinnati & Hamilton County Public Library.)

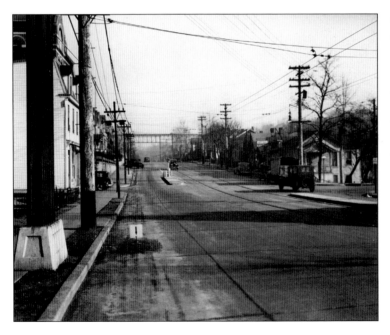

This northbound view of Delta Avenue shows the Grandin Road Bridge in the background. To the right, at the intersection of Widman Place, is 442 Delta Avenue. It was built in 1885 and is still a residential home today. Next door, to the north, was Lincoln Confectionery at 444 Delta Avenue. (Courtesy of the General Photographic Collection-Suburbs [SC#59], Cincinnati Museum Center.)

In this close-up of the Delta Viaduct, a loading platform is visible in front of 588 Delta Avenue. Loading platforms throughout the city became notoriously hazardous. According to a coroner's report, from 1927 to 1929, over 10 people were killed when they crashed their automobiles into the platforms. (Courtesy of Phil Lind.)

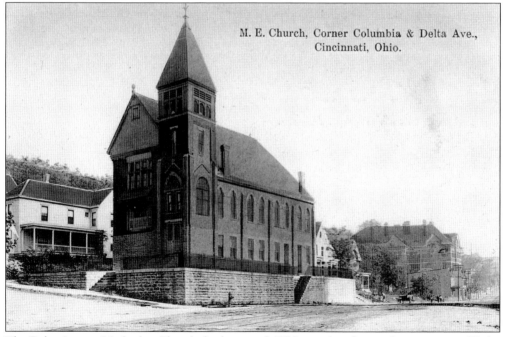

The Delta Avenue Methodist Church, built around 1880, stood at the northwest corner of Delta Avenue and Columbia Parkway, where the Delta Flats condominiums are now. The Lincoln Public School can be seen north along Delta Avenue. This image is dated 1910. The church was torn down in the late 1970s. Edna DeGarmoe was the organist from 1915 to 1963. (Courtesy of the Cincinnati & Hamilton County Public Library.)

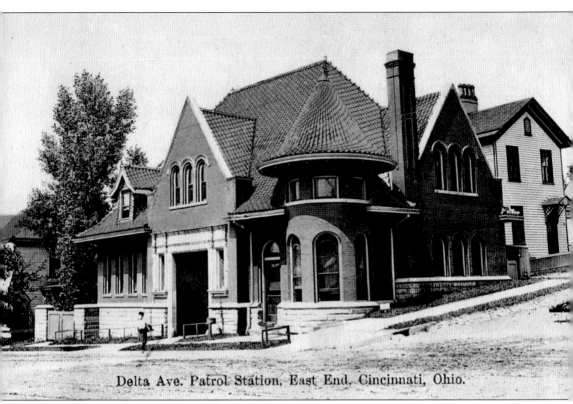

Delta Ave. Patrol Station, East End, Cincinnati, Ohio.

Cincinnati Police Patrol House No. 6 still stands at the southwestern corner of Columbia Parkway and Delta Avenue. When it was built in 1888, it was a two-officer patrol house with a wagon and a stable for horses. The police station, which had jail cells, was located at 3855 Eastern Avenue. At that time, most police officers walked the neighborhood on foot. The purpose of the patrol house was to dispatch a horse and wagon if there was a need to transport a criminal or someone who was injured. In 1950, when the District 2 station was completed at 3295 Erie Avenue, the old patrol house was vacated by the police department. In 1981, restaurateur Jeff Ruby converted the building into his first steakhouse, called the Precinct, and it has been successfully running ever since. (Courtesy of the Cincinnati & Hamilton County Public Library.)

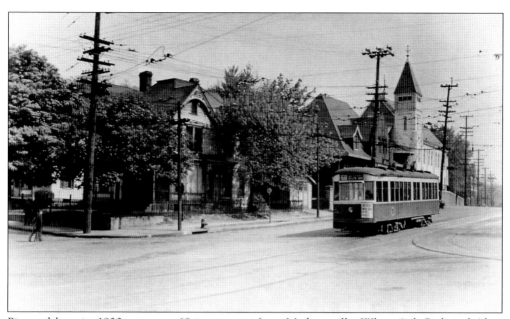

Pictured here in 1930, streetcar 68 is en route from Madisonville. When Ault Park and Alms Parks were first established, passengers took this streetcar to a bus or car that transported them the remainder of the way. In this image, the Precinct restaurant was still used as Cincinnati Patrol House No. 6. On April 29, 1951, the streetcars of Cincinnati ran their last routes. (Courtesy of Phil Lind.)

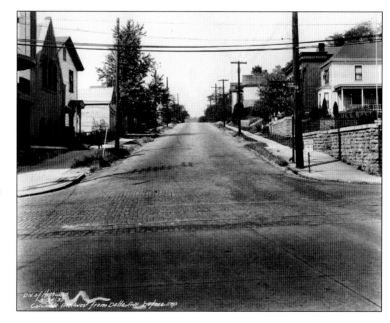

This photograph, taken in 1937, shows Columbia Parkway looking west from Delta Avenue before construction to improve the parkway had begun. Unlike today, many stretches of this road were residential. To the left, Cincinnati Police Patrol House No. 6 (today Jeff Ruby's Precinct restaurant) is just slightly visible. (Courtesy of Archives and Rare Books Library, University of Cincinnati.)

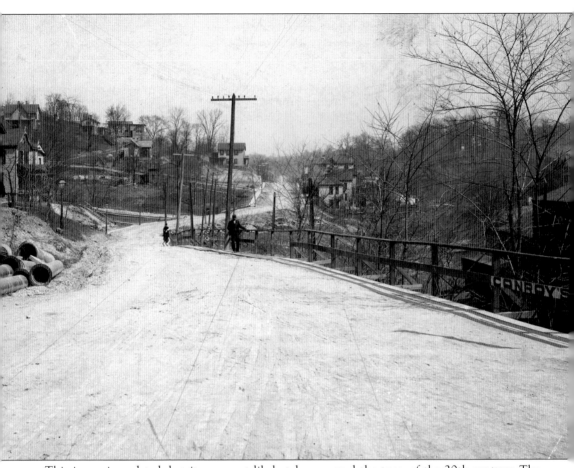

This image is undated, but it was most likely taken around the turn of the 20th century. The view is looking east on US Route 50 (Columbia Parkway) from Delta Avenue. Before the parkway was built, it was a narrow, unpaved road called Columbia Avenue. Most of the buildings shown here are no longer standing. This picture shows the bridge on Columbia Avenue that was built over Crawfish Creek, which flowed down along Delta Avenue from the top of the hill. The advertisement on the bridge is for Conroy's Furniture Store, which opened downtown in 1881. While Mt. Lookout residents could shop locally for certain needs, going downtown was still a necessity for big purchases such as furniture. (Courtesy of the General Photographic Collection-Suburbs [SC#59], Cincinnati Museum Center.)

Michael Conaway took this picture in 1975 just before the Grandin Road Bridge was demolished. At the time, he was a high school student who was interested in photography. When Conaway heard about plans for the bridge to come down, he seized the opportunity to capture a bit of history in this photograph. For decades, the bridge was a subject that residents could not agree on. City officials justified their choice of demolition over repairs because of the cost and the fact that ambulances and fire trucks did not use the bridge in their routes. While some residents voiced their opposition to tearing the bridge down, others were glad to see it go due to kids throwing things onto Delta Avenue below. This image was taken from the bridge with a southwestern view of Delta Avenue. Many of the homes shown here are still standing. (Courtesy of Michael Conaway.)

As shown in this picture, the Grandin Road Bridge had a sidewalk for pedestrians and bridge railings for safety. However, it was safety issues that seemed to plague the bridge early on. While numerous suicides were a valid concern, evidence of the bridge's structural weakness was a greater problem. During World War II, the first proposal for demolition was considered. It was suggested that the metal from the bridge, in excess of one million pounds, could be used to help the war effort. Several repairs were made over the years, but by the 1970s, rampant rust and deterioration had claimed the bridge for good. The Mt. Lookout Community Council argued in favor of making new repairs or replacing the structure altogether; the main concern was that the absence of a bridge would increase traffic on Linwood Avenue and Delta Avenue, especially in Mt. Lookout Square—which it ultimately did. (Courtesy of Michael Conaway.)

Two
EARLY GROWTH AND DEVELOPMENT

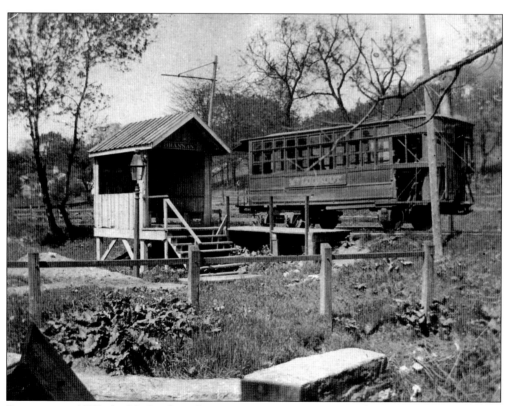

Beginning in 1872, the Mt. Lookout Dummy was a steam car service that traversed up and down Delta Avenue, connecting with another line that went downtown. Brannan Station was located on the western side of present-day Mt. Lookout Square. Before businesses began to appear in the square, some residential homes were built there. (Courtesy of the Cincinnati & Hamilton County Public Library.)

Mount Lookout Dummy
DIED
JULY 4th, 1897 at 11:30 A. M.
Cremation Service
to be held January 1st, 1898,
at MT. LOOKOUT PARK,
at 5 P. M.
Funeral Public—All Friends Invited.

The old oaken dummy, the iron bound dummy,
The steam leaking dummy, on its trembling old rails,
It sputtered and rumbled o'er bridges and gullies
While to keep to its schedule it signally failed.
With dogs and with cattle for speed it did battle
And shrieked till the forest resounded with noise,
But its age was against it, its rivets were rusted
No longer it's classed as one of the boys.
So here's to the past of the old oaken dummy
And peace to its ashes, when it ends its career.
Though fast, there are others much faster than it was,
And Electrics will carry the poor dummy's bier.

Music from 4 to 6 P.M. Services will close with a Funeral Dirge by the Columbia Band. Fireworks, Firing of Cannon and Refreshments at the Park, under the auspices of Judge Burch, assisted by the Gardener and Poet of the Piccadilly Club.

The original purpose of the Dummy was to lure people to Mt. Lookout from downtown. John and Charles Kilgour helped develop Hyde Park and Mt. Lookout. Thanks to the steam Dummy, more people began to purchase property and build homes. Service ended in 1897 when it was replaced by newer technology. (Courtesy of Cincinnati Museum Center.)

Anna Bangs, a Vanderbilt cousin, lived in a dilapidated shack on Brookfield Avenue. According to a 1901 *Cincinnati Post* article, this was the oldest home in Hamilton County at the time. Judge Howard Ferris eventually ordered Bangs to report to a widows' home because of her poor living conditions. (Courtesy of the *Cincinnati Post* Collection, Cincinnati Museum Center.)

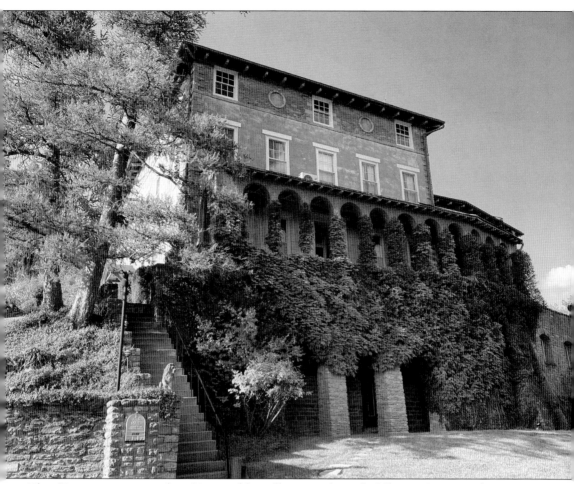

This 17-room mansion, with its Norman-like walls, sits at the end of Shattuc Avenue and garners magnificent views of the valley. It was built around 1830 by Jacob Feck. Prior to that, the land had been owned by the first Nicholas Longworth, who was famous for his Catawba winemaking. Feck, a German immigrant, continued to grow grapes and make wine until the 1850s, when black rot destroyed most of the grapevines. After that, he started the Suburban Ice Company. In 1917, "Crusade Castle," as it became known, was purchased by the Catholic Church. From 1923 to 1978, it was occupied by the Catholic Student Mission Crusade Headquarters. The wine cellars were converted into chapels. In 1978, the property was sold to Donald and Mabelle Attermeyer, who reverted the mansion back into a residential home. However, since then, the house was sold to Ark by the River Church on Eastern Avenue. (Courtesy of the author.)

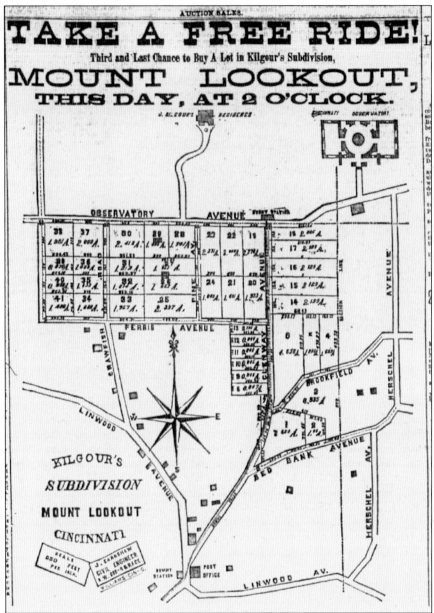

This advertisement for Kilgour properties was printed in 1873. John Kilgour owned a great deal of real estate that he sold off. The Kilgour estate, called the Pines, could be reached via a lane from Observatory Avenue. Erie Avenue had not yet been built. At the time of this map, Paxton Avenue (far left) did not connect south to Linwood Avenue as it does today. Many street names have changed over the years: Griest Avenue was called Ferris Avenue, and Hardisty Avenue was called Red Bank Avenue. Interestingly, this map contradicts other documents from the time in that it identifies Delta Avenue as Glenway Avenue instead of Crawfish Road. Brookfield Avenue is somewhat of a mystery; many sources refer to it as a "paper street," which means the road was never actually built. However, there are many references to homes on Brookfield Avenue, and today the Hamilton County Auditor lists four properties on Brookfield Avenue. (Courtesy of the Cincinnati Observatory.)

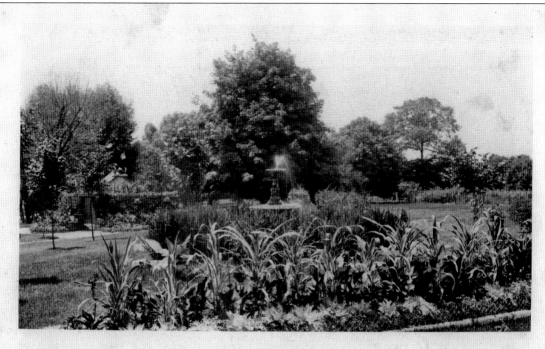

ST. JOHN'S PARK—MT. LOOKOUT.

At the north end of Delta Avenue were St. John's Park and Mt. Lookout Park. St. John's Park, named after John Kilgour and owned by the Kilgour family, was situated at the southwest corner of Delta Avenue and Erie Avenue. In 1951, a grand Art Deco home was built there at 3095 Erie Avenue for George and Najla Joseph and their six children. Mt. Lookout Park was located south of St. John's Park, between Observatory Avenue and Griest Avenue. The park was purchased in 1892 by a local man, John Wuebker, who lived on Willis Avenue. In 1900, it was announced that a new road, Springer Avenue, was to be built in an east-west direction from Delta Avenue to Grace Avenue by going through Mt. Lookout Park. Soon after, homes were built along Springer Avenue. Over the years, the names Mt. Lookout Park and St. John's Park have been used interchangeably, but they were in fact two different parks. (Courtesy of the General Photographic Collection-Suburbs [SC#59], Cincinnati Museum Center.)

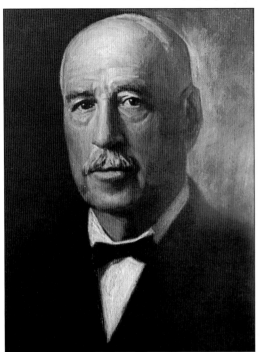

John Kilgour (1834–1914) boasted an impressive résumé. He invested in real estate in Hyde Park and Mt. Lookout, he was head of the Cincinnati Bell Telephone Company as well as the Cincinnati Street Railway, he donated land and money for the Cincinnati Observatory to be built, and of course, the John Kilgour Public School is named after him. (Courtesy of Kilgour Elementary.)

John Kilgour lived at the Pines residence for over 50 years. The sprawling estate originally faced Observatory Avenue, stretching from Delta Avenue to Paxton Avenue. In 1893, some of the land was sold to build Erie Avenue, which substantially reduced the property's front acreage. The history of this land goes back to 1795, when it was purchased by Thomas C. Wade from John Cleves Symmes. (Courtesy of Mike Judy.)

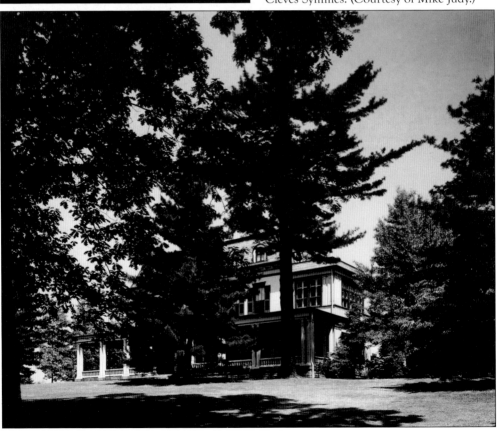

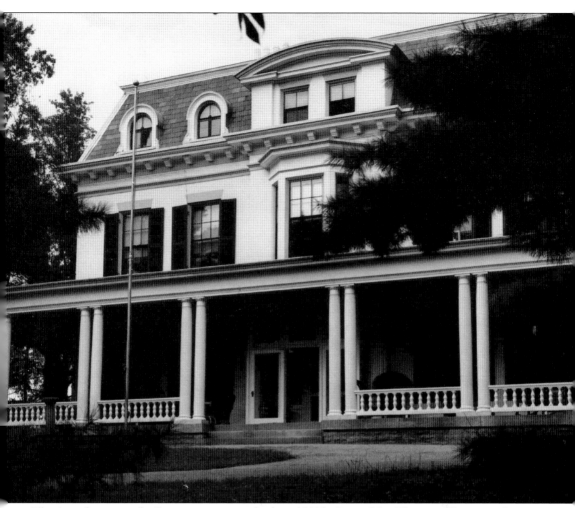

The main house on the Pines property was built in 1818 by James Hey. He named his estate Beau Lieu Hill Farm. In French, *beau lieu* means "beautiful place." According to a letter written by one of his relatives at the time, James Hey was buried on the highest point of the original property, next to two large oak trees (near present-day Bayard Avenue). It was John Kilgour who, after purchasing the property in 1863, changed the name to the Pines because of all the towering pine trees that covered the estate. In 1939, the Kilgour family sold the estate to Myers Y. Cooper. He was a local real estate developer, and he also was elected the 51st governor of Ohio. After Cooper purchased the Pines, he parceled off more lots to build Bayard Avenue and Raymar Boulevard. This image was taken in 1920. (Courtesy of Mike Judy.)

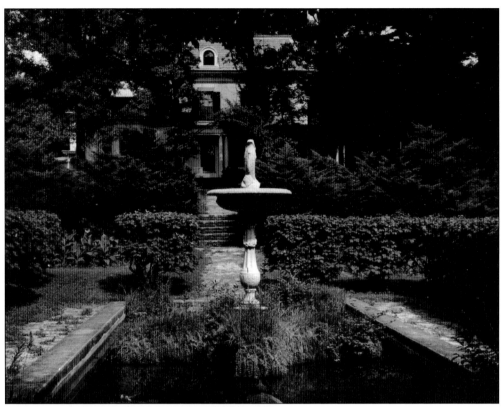

This was one of the fountains at the Pines residence. In addition, the property included beautiful gardens, two swimming pools, multiple garages, horse stables, chicken coops, and even a dance pavilion, which, when not being used for evening parties, served as a great roller-skating rink for all the children and grandchildren who grew up here throughout the years. (Courtesy of Mike Judy.)

This was the service driveway to the Pines, taken in 1920. The Pines address was 3030 Erie Avenue. In the mid-1960s, the house and remaining property were taken via eminent domain, and the Cincinnati Board of Education razed the Pines to build Walter Peoples Middle School. Thirty years later, the school closed and was replaced by Clark Montessori. (Courtesy of Mike Judy.)

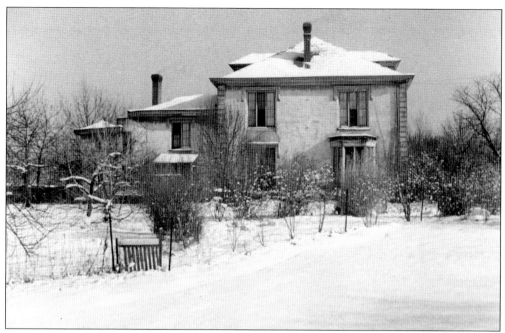

The property at 3539 Principio Avenue was built in the mid-1800s, when Ault Park was still just privately owned land. It stood at the eastern end of Principio Avenue, which was once a brick road. The house was torn down in 1954, and two new homes were built on the property. (Courtesy of the General Photographic Collection–Suburbs [SC#59], Cincinnati Museum Center.)

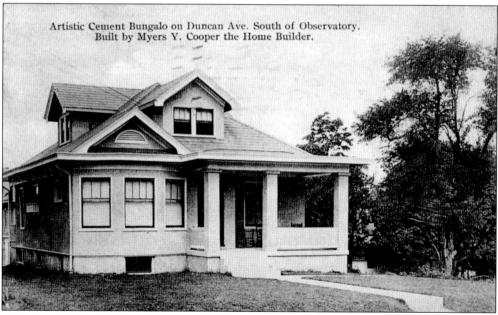

Myers Y. Cooper (1873–1958) was a successful real estate developer in Hyde Park and Mt. Lookout; later he was elected the 51st governor of Ohio. Cooper started the Hyde Park Lumber Company and built many homes, including this one at 1341 Duncan Avenue in 1924. Cooper purchased the Pines residence on Erie Avenue from the Kilgours. (Courtesy of the Cincinnati & Hamilton County Public Library.)

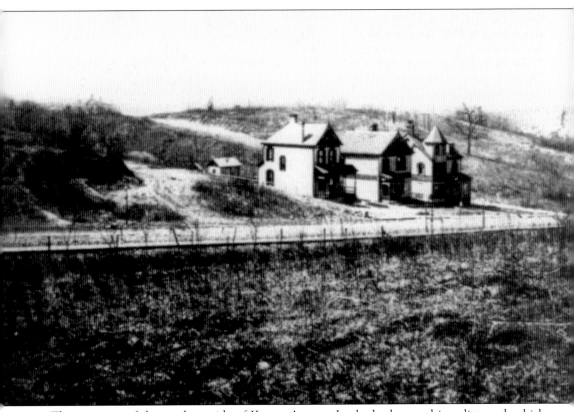

This is a view of the southern side of Kroger Avenue. In the background is a dirt road, which is now Overland Street. In the late 1800s, this area was known as Tusculum Heights. All three homes are still standing today. Built on the corner in 1880, the home on the far right is 3573 Kroger Avenue. This house has been owned by the Woeste family as far back as the early 1900s. Joseph H. Woeste lived there until 1964, and George Woeste resided there at the time of his death in 1976. Currently, the home is owned by John and Janet Woeste. Joseph H. Woeste was not the same person as—nor was he related to—Judge Joseph H. Woeste of Cincinnati (1891–1958). Kroger Avenue was renamed in honor of Bernard H. Kroger, founder of the grocery store chain, who opened his first store in Cincinnati in 1883. The 12-acre Kroger family estate, called Slantacres, was situated nearby at Stanley Avenue and Vineyard Place. (Courtesy of Ryan Wenstrup-Moore.)

The house at 3575 Kroger Avenue was constructed in 1890. It was the Sparkes family's residence from the 1940s to 1970s. Bernadette Sparkes, known as "Sparkie," was the director of the Oakley Senior Citizens Center for 17 years. She was very involved in local charities, including Children's Hospital and Red Cross. Sparkes died in 1977. (Courtesy of Ryan Wenstrup-Moore.)

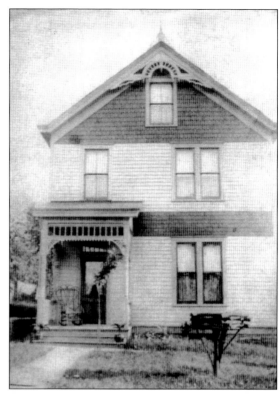

The house at 1296 Crestwood Avenue (originally called Jenks Avenue) was the first to be built on this street. It extends north from Principio Avenue and connects with Aultwoods Lane. Parker and Hazel Melvin owned this home from 1938 to 2013. This image was taken in 1938. (Courtesy of Archives and Rare Books Library, University of Cincinnati.)

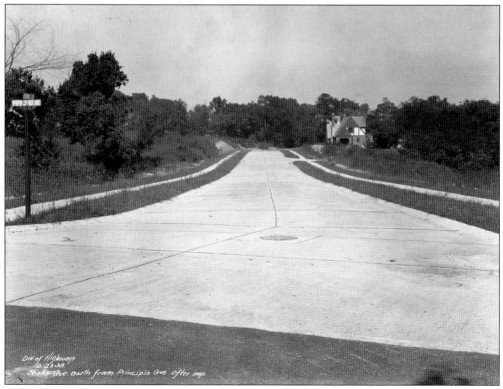

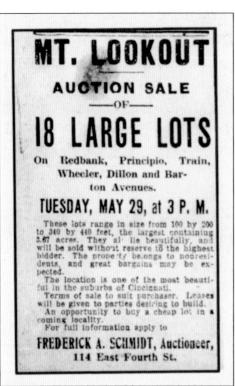

This advertisement appeared in the *Cincinnati Post* in 1906. Redbank Avenue (not to be confused with Red Bank Road) is called Aultwoods Lane today. Train Avenue is now called Brookwood Meadow, which, according to maps, originally connected farther east with Dillon Avenue. Ault Park had not yet been developed, but it would soon be just a stone's throw away. (Courtesy of the *Cincinnati Post* Collection, Cincinnati Museum Center.)

The house at 1215 Hayward Avenue was one of the first to be constructed on this street in 1934 and was built by Myers Y. Cooper. The original owners were Michael and Mary Marx. From 1940 to 1973, William and Vera Kreidler resided here. This view is looking north from Arnold Street prior to road improvements. (Courtesy of Archives and Rare Books Library, University of Cincinnati.)

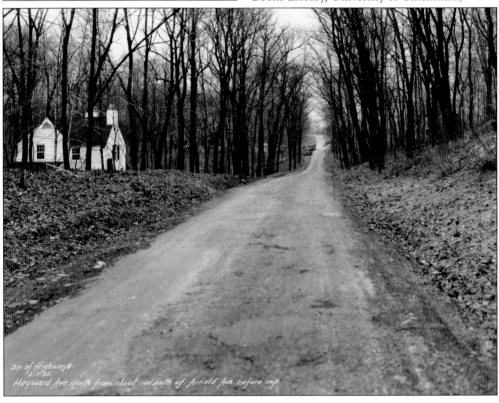

Frank Boesch is an important name in Mt. Lookout. In 1901, Boesch (1878–1966), affectionately known as "Mr. Mt. Lookout," purchased several acres of land on the western side of Mt. Lookout Square when it was just a rural, undeveloped community. Today, his descendants still own his properties, including Stereo ADV, the CVS building, and the old theater, which is now doing business as the Redmoor Event House. Boesch and his family lived at 2995 Observatory Avenue, shown here; his wife, Maria McDonald Boesch, grew up here and inherited the house, which was built in 1880. It has been lived in by generations of the McDonald-Boesch family for over 120 years. (Both, courtesy of Debbie Wessel.)

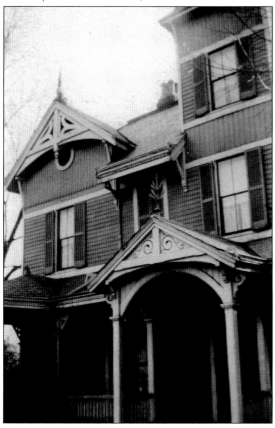

George H. Rohde is a name that nearly everyone in Mt. Lookout knows. His first funeral home was built on Eastern Avenue. In 1920, Rohde relocated to the newly established Mt. Lookout Square. It is a building that saw the square grow and flourish around it. Rohde died at only 55 years old in 1938. His first successor was his son John H. Rohde, followed by John H. Rohde Jr. ("Don") and the current director since 2002, Steve Rohde. The Rohde family has been actively involved in the Mt. Lookout Community Council. (Both, courtesy of Geo. H. Rohde & Sons Funeral Home.)

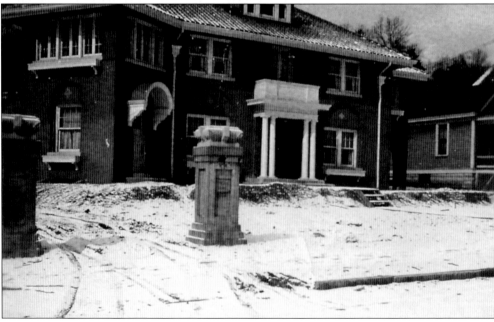

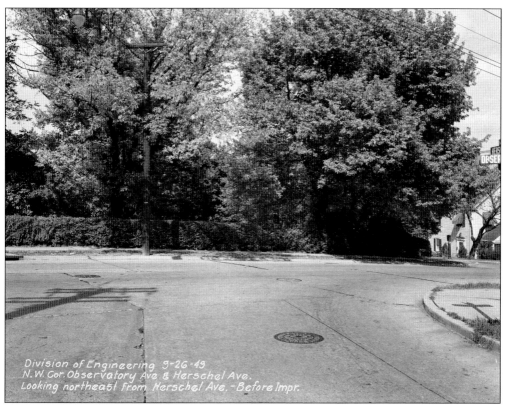

Prior to 1950, the intersection at Observatory Avenue and Herschel Avenue looked very different than it does today. This image was taken from Herschel Avenue facing north. Drivers had to turn east on Observatory Avenue and then immediately turn north to stay on Herschel View Avenue. The house on the right is 3404 Observatory Avenue, which was built in 1905. (Courtesy of Archives and Rare Books Library, University of Cincinnati.)

The invention of the automobile and the improvements to Columbia Parkway allowed Mt. Lookout to grow during the early 20th century. Staircases were built into the walls so that people living in homes on the hillside could easily access public transportation. By the early 2000s, the stairs were walled off, but passersby can still see their ghostly outlines left behind. (Courtesy of Archives and Rare Books Library, University of Cincinnati.)

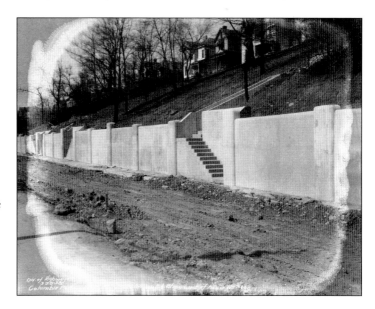

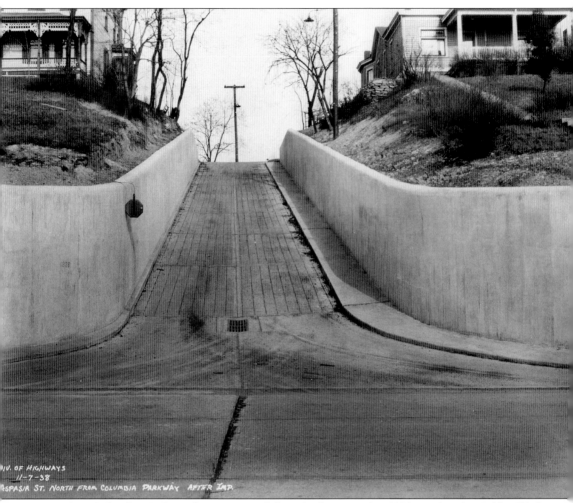

Before Columbia Parkway became a multilane highway in the 1930s under the Public Works Administration, it was a narrow, uneven road called Columbia Avenue. A major part of this construction project included the installation of substantial retaining walls along the northern side. Columbia Parkway and Golden Avenue run parallel to one another in east-west directions, and Aspasia Street once connected them (shown here in 1938). At its southern end, Aspasia Street was walled off in 1975 due to the high traffic on Columbia Parkway. After that, the alley behind these homes could only be accessed from Aspasia Street via Golden Avenue. The home on the left, 3250 Columbia Parkway, was built in 1890. On the right, 3300 Columbia Parkway was built in 1885. The steps are still there, but they lead to a dead end at the bottom of the hill. Both homes are still standing; however, many homes along Columbia Parkway were remodeled because what was once considered to be the front entrance has become the rear. (Courtesy of Archives and Rare Books Library, University of Cincinnati.)

Three
THE OBSERVATORY

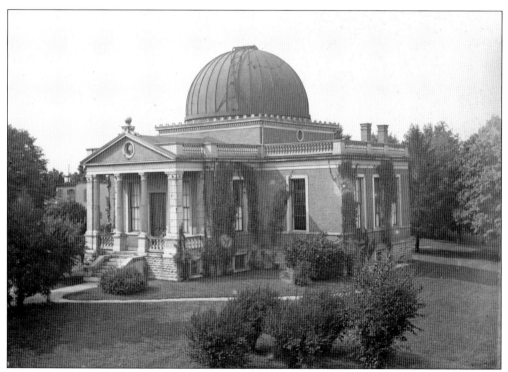

Completed in 1873, the new Cincinnati Observatory was built at 3489 Observatory Place. Philanthropist John Kilgour donated money and land for the building as well as a new road, Avery Lane. The village called Delta changed its name to Mt. Lookout because people could "look out" at the night skies. (Courtesy of the Cincinnati Observatory.)

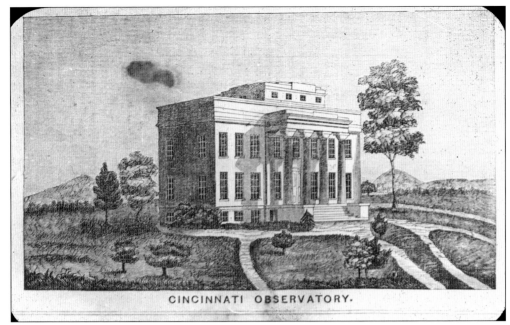

CINCINNATI OBSERVATORY.

The Cincinnati Observatory is the oldest in the United States. The original structure, shown above around 1845, was built in Mt. Adams (then called Mt. Ida). Nicholas Longworth (1783–1863), best known in Cincinnati for his vineyards and wine, gifted several acres. Former president John Quincy Adams came to Cincinnati and gave his final speech at the dedication. After that, Mt. Ida became known as Mt. Adams. However, within 30 years, the city determined that a new observatory should be built in the suburbs because there was too much pollution near downtown. Below, the new observatory was completed in 1873. Samuel Hannaford was the architect who designed the Neoclassical building. (Both, courtesy of the Cincinnati & Hamilton County Public Library.)

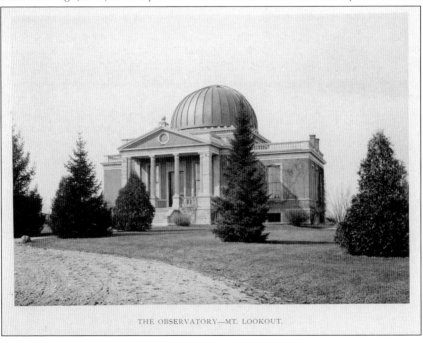

THE OBSERVATORY—MT. LOOKOUT.

The original telescope in Mt. Adams came from Munich, Bavaria. It was found by Ormsby MacKnight Mitchel, who became the first director of the Cincinnati Observatory. When the new building was constructed in Mt. Lookout, the telescope was transplanted from Mt. Adams. However, it was eventually replaced in 1904 with an Alvan Clark and Sons 16-inch refracting telescope. (Courtesy of the Cincinnati Observatory.)

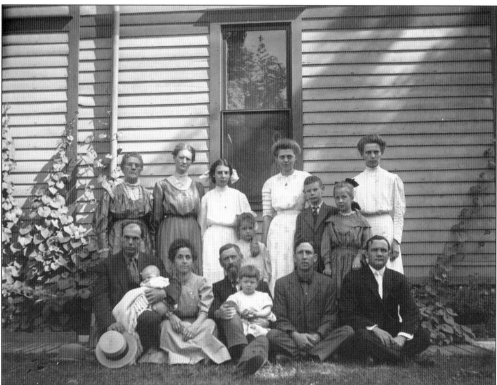

Jermain G. Porter (center, holding the child) was one of the early astronomers and directors who lived on the grounds of the Mt. Lookout Observatory. He is photographed here with his family in front of his home. Several articles were printed in 1910 about Porter and the observatory regarding Halley's Comet. In fact, Cincinnati's first image of the comet was captured at the observatory. (Courtesy of the Cincinnati Observatory.)

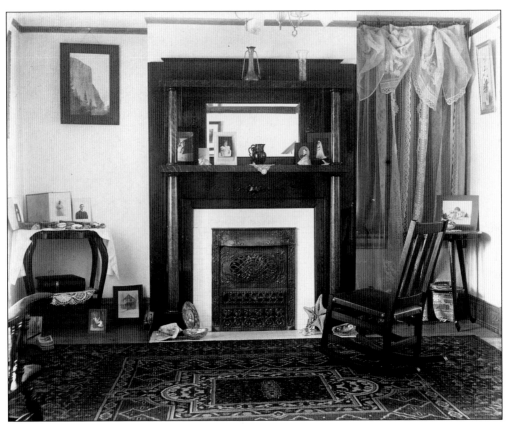

This was the living room and dining room of Prof. Elliott Smith in about 1910. Smith was hired as an assistant astronomer at the observatory, and later he became the director, a position he held from 1940 to 1943. Louise Strautman also worked there as an assistant astronomer. On June 7, 1907, an article in the *Cincinnati Post* announced their engagement; they were married later that year. In 1943, Elliott was discovered hanging from the telescope inside the observatory. He left no note, although he had disclosed an illness that required surgery. In the living room, on the far right, notice the framed picture on the table of the observatory. (Both, courtesy of Cincinnati Observatory.)

Harriet Smith, daughter of Dr. Elliot and Louise Smith, was born in 1909. She grew up to marry Paul Herget, who took over as director of the observatory following the death of her father in 1943. This photograph was taken around 1914. The house in the background sits on the corner of Observatory Avenue and Observatory Place. (Courtesy of Cincinnati Observatory.)

In the 1890s, this house was mistakenly built on observatory grounds. However, the house was purchased by the observatory and used by the directors and their families. The home faced Avery Lane; today, there remains a gravel path where the driveway was. The house was demolished some time in the 1960s. In this c. 1910 image, the observatory is slightly visible on the right. (Courtesy of Cincinnati Observatory.)

This Victorian home has perched high on the hill at 3300 Observatory Avenue since the late 1800s. It was the home of observatory director Ormond Stone. He moved to Cincinnati in 1875 and became the third director of the Cincinnati Observatory. Prior to that, he had worked as an astronomer in Washington, DC, for the US Navy. (Courtesy of the author.)

The Cincinnati Observatory was built at the end of Observatory Place, shown here from the snowy intersection at Observatory Avenue. Avery Lane once intersected with Wellston Place all the way down to St. John's Place. The observatory was the first in the country to collect weather data and report it in daily newspapers. This picture was taken around 1910. (Courtesy of Cincinnati Observatory.)

Four

AULT PARK

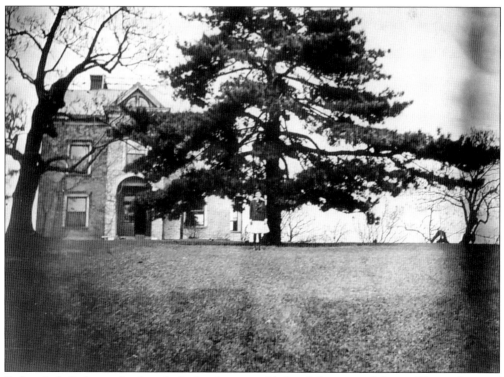

Before Ault Park was developed, the land was speckled with homes and farms. The residence of William M. Monroe, pictured here around 1900, was called Greystone. It had a spacious rooftop deck that offered panoramic views, including that of the Little Miami River valley to the east. Until the pavilion was built in 1930, visitors came to the Monroe house for sightseeing opportunities. (Courtesy of Cincinnati Parks Library and Archives.)

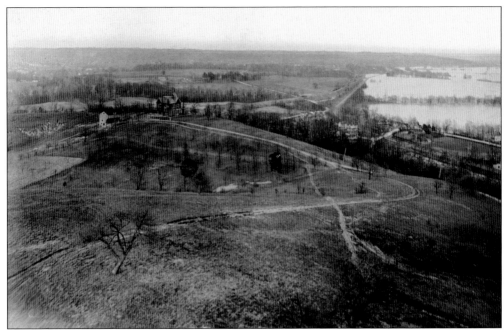

This northeast view from the top of the Monroe house was taken during the flood of 1913. The deluge of the Little Miami River is visible to the right. The house in this image sits where the caretaker's house is located now; the driveway is still used today. The Monroe house stood northwest of the pavilion, facing south. (Courtesy of Cincinnati Parks Library and Archives.)

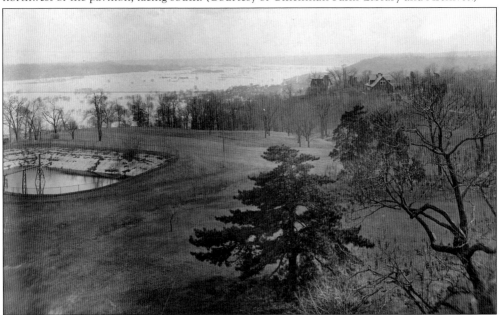

This is another photograph taken from the Monroe house during the 1913 flood. Before it was named Ault Park, this area was known as Linwood Heights. To the left, the Linwood Reservoir was eventually filled in, and the pavilion was built on that spot. The Monroe house had a view of the Heekin home (background, left) and the Andrews home. (Courtesy of Cincinnati Parks Library and Archives.)

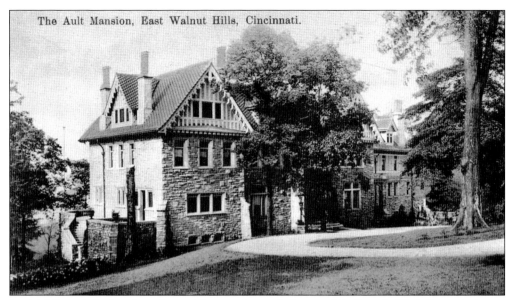

Levi Addison Ault, for whom the park is named, was chairman of the Board of Park Commissioners for almost 20 years. His wife, Ida May Ault, named their mansion in East Walnut Hills Millie Roche. Following their deaths, the house and property were sold to create a new subdivision of homes and a new street called Melville Lane. (Courtesy of the Cincinnati & Hamilton County Public Library.)

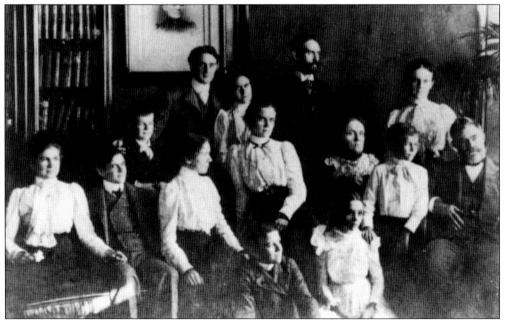

James Heekin (1843–1904) founded the Heekin Can Company. He and his wife, Mary, had 15 children. Today, the Heekin Overlook at Ault Park marks the approximate location of where their home stood. Pictured are, from left to right, (first row) Daniel and Eileen; (second row) Mary Alice, Robert, Stella, Nora, Mary (mother), Herbert, and James (father); (third row) Walter, Albert, Helena, James, and Loretta. Heekin Avenue runs from Ault Park to Eastern Avenue. (Courtesy of Maureen Heekin.)

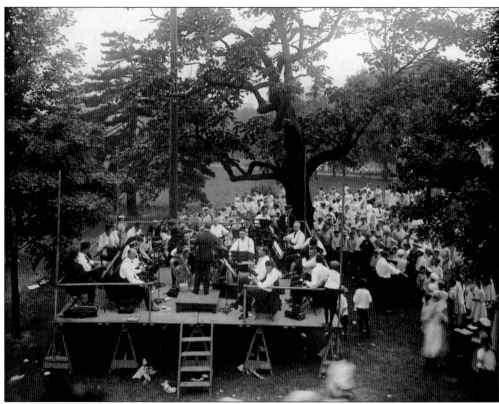

Ault Park has always been known for its public events such as band concerts and dances. Here, a crowd has gathered at a Labor Day picnic in 1915. There was a contest for the largest family in attendance; the winner was John G. Gordon and his eight children. This view is looking down from the Monroe house in the front yard. (Courtesy of Cincinnati Parks Library and Archives.)

This is an image of 3539 Principio Avenue at the intersection of Heekin Avenue. This home was demolished in the 1950s, and two homes took its place shortly thereafter. Before Observatory Avenue was extended east of Herschel Avenue, this was Ault Park's main entrance and exit. Levi Ault, who donated most of the land, stipulated that Principio Avenue was to be improved as part of the deal. (Courtesy of Kenton County Public Library.)

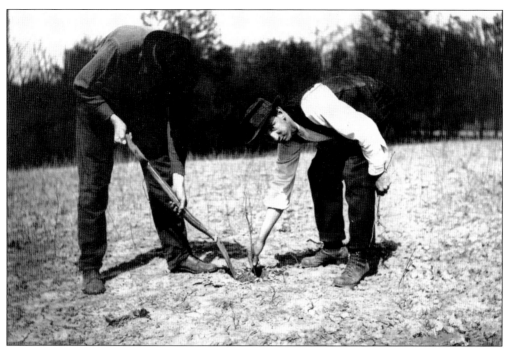

The men shown here are planting trees in Ault Park in 1913. Plans for formal gardens were initially designed by George Kessler and then modified by A.D. Taylor. Both men were renowned landscape architects. Taylor's plans were ultimately selected and carried out. In 1935, a wealthy man from Japan named Hazime Hoshi gifted 700 Japanese cherry trees to the park. (Courtesy of Cincinnati Parks Library and Archives.)

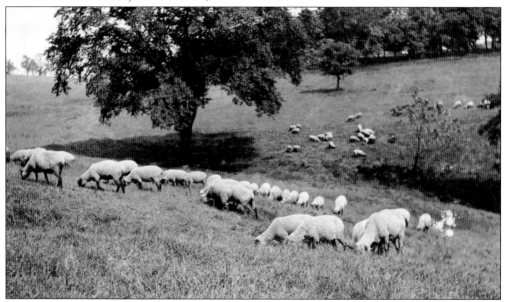

In the early 1900s, it was very common to see lots of sheep roaming about Ault Park, as they helped to keep the grounds manicured. Levi Ault first donated 142 acres of land in 1911. By 1934, the park had increased in size to 224 acres. (Courtesy of the General Photographic Collection–Suburbs [SC#59], Cincinnati Museum Center.)

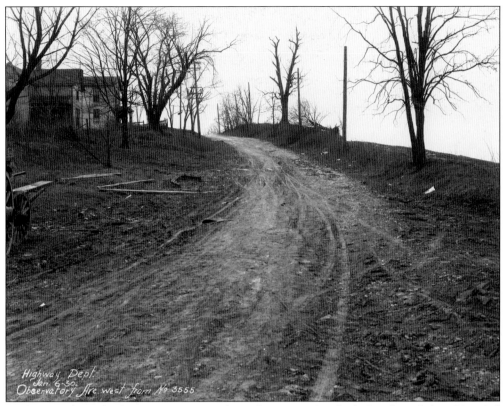

At first, eastbound Observatory Avenue (once known as Hogback Road) ended at Herschel Avenue. When Ault Park opened, the road was extended. When the pavilion was being built, the park board convinced city officials to widen and improve the road. This image from 1930 shows westbound Observatory Avenue before improvements. The property at 3529 Observatory Avenue was built in 1895. (Courtesy of Archives and Rare Books Library, University of Cincinnati.)

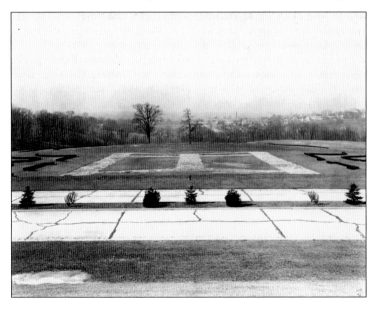

This picture was taken in 1929 during the construction of the pavilion. From this spot, park visitors had an unimpeded view of the John Kilgour Public School (background center), which had just recently been built in 1922. The street east of Herschel Avenue is Aultwoods Lane, previously called Redbank Avenue. (Courtesy of Cincinnati Parks Library and Archives.)

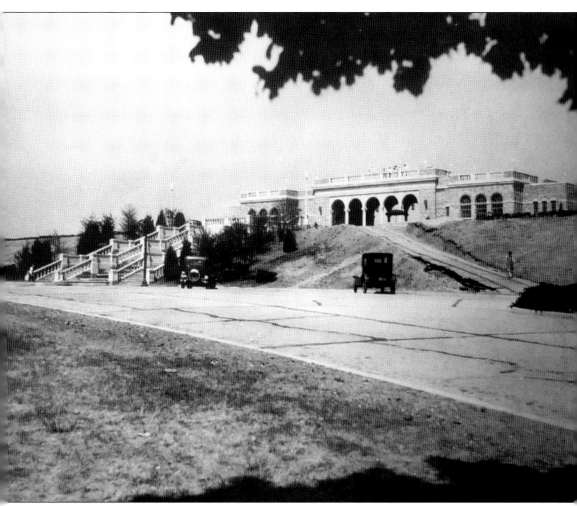

Although best known for his philanthropy, Levi Addison "L.A." Ault was president of Ault & Wiborg Company. In 1911, the majority of the acreage to create the park was donated by Ault and his wife, Ida May Ault. At that time, it was an area called Linwood Heights. Before gifting the land to the city, Ault purchased tracts from a number of owners. He wrote checks to Mary Heekin, Emma B. Thompson, William Monroe, Eleanora W. Langdon, Mary A. Nolan, and others. According to Cincinnati Parks Library and Archives, Ault said of the park, "Here is a million dollar view worthy of a structure of no lesser beauty than the Parthenon." The Italian Renaissance-style pavilion was completed and dedicated on July 4, 1930, with the help of the Mt. Lookout Community Council. Originally, a driveway was built in front of the pavilion, but it was later removed. L.A. Ault died in 1930 just a few months before the pavilion was dedicated; Ida May died in 1931. (Courtesy of Ault Park Advisory Council.)

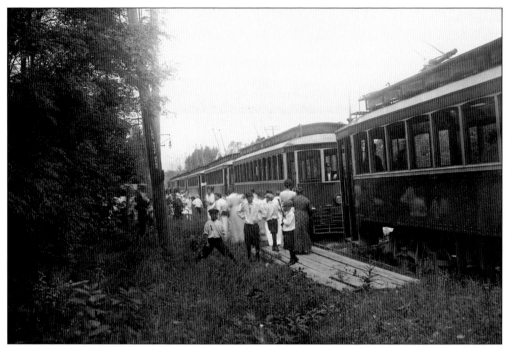

Starting in 1933, the Cincinnati Street Railway Company coordinated a motor coach schedule to work in conjunction with the streetcars so that people had easy transportation to Ault Park. The last shuttle left each night at midnight, dropping passengers off at the streetcar station at St. John's Park on the corner of Delta and Erie Avenues. (Courtesy of Cincinnati Parks Library and Archives.)

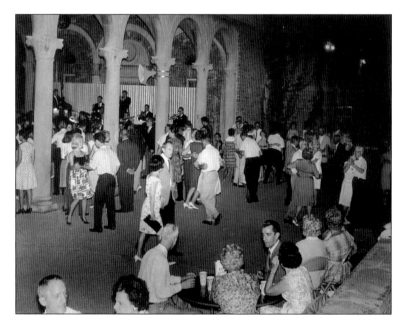

For 30 years, dance parties at the Ault Park pavilion were wildly popular. From the 1930s to the 1960s, there was a live band and a full-course dinner every night (except Mondays) until midnight. On July 23, 1966, Denny Heglin performed with his band. Admission was $1. (Courtesy of Ault Park Advisory Council.)

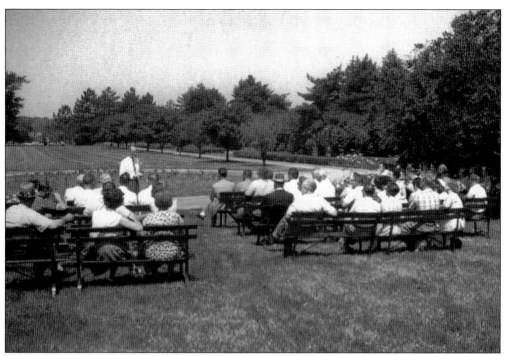

Dalton W. Battin was superintendent of city parks. In 1958, a rose garden was planted in the northern garden. Battin presented at a public rose clinic at Ault Park in 1960, shown here. By the 1970s, the park was not exactly safe at night. Gangs made the park their hangout and brought vandalism with them. As a result, Battin requested additional police supervision. (Courtesy of Cincinnati Parks Library and Archives.)

Celia May Brumm (right) was a well-known volunteer for Cincinnati Parks. Pictured here in 1980, she was the first person to "adopt a plot" at Ault Park. She graduated from the University of Cincinnati College of Medicine in 1940, but her love of gardening was her true passion. After Brumm's death in 1994, a memorial garden was named in her honor. (Courtesy of Cincinnati Parks Library and Archives.)

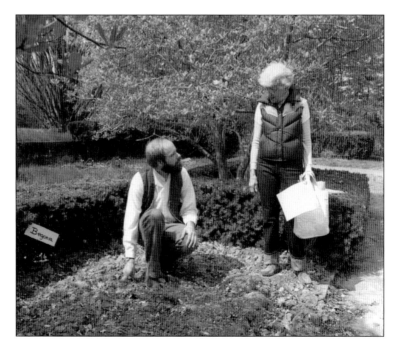

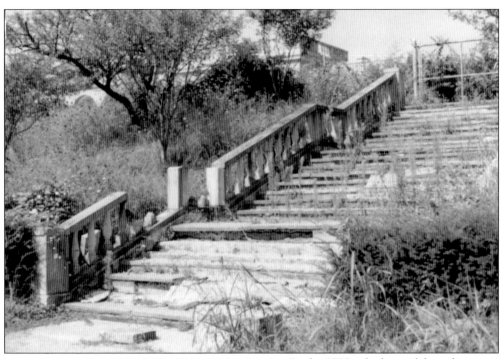

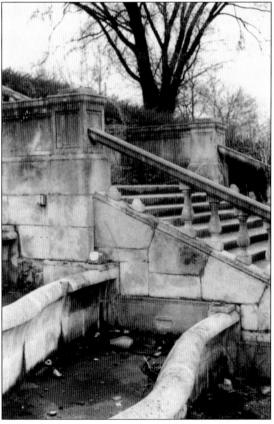

By the 1970s, the beautiful pavilion, as well as the park grounds, had fallen into terrible disrepair. Shrubs and weeds covered the pavilion, and a chain-link fence was put up at the top of the stairs. Local residents united to protect and rehabilitate Ault Park. The Ault Park Advisory Council was formed in 1985 by Rob Kranz, Monica Nolan, Mae Rieser Sreitmann, and others. Initially, the group hoped to raise around $50,000; by 1986, a total of $150,000 was collected in contributions. Major repairs were made to the staircase and railings, cascade fountain, rooftop, doors, and windows. (Both, courtesy of Cincinnati Parks Library and Archives.)

Monica Nolan raised funds to renovate the cascade fountain in memory of her sister, Nora May Nolan, who taught English for 23 years at Withrow High School. For many years, it was Nora May who organized fireworks and band concerts for the Independence Day celebration, which, until recently, took place each year on July 3 instead of July 4. (Courtesy of Cincinnati Parks Library and Archives.)

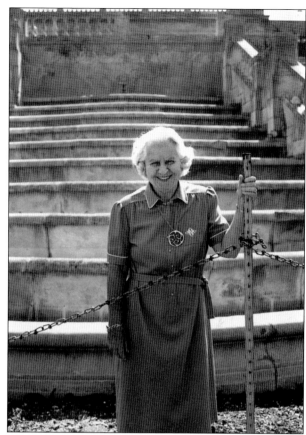

After 20 years of dormancy, the cascade fountain in front of the pavilion came to life again. The celebration was held on July 4, 1985, exactly 55 years after the Italianate pavilion was dedicated. Children filled the fountain tiers with water before the circulation pumps were activated. (Courtesy of Cincinnati Parks Library and Archives.)

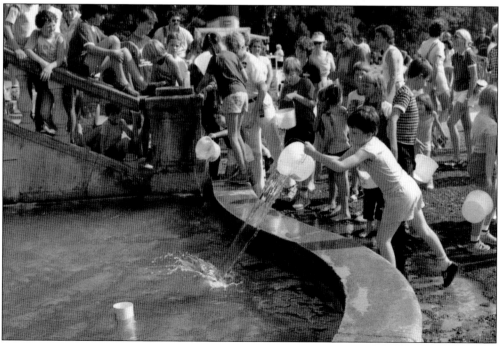

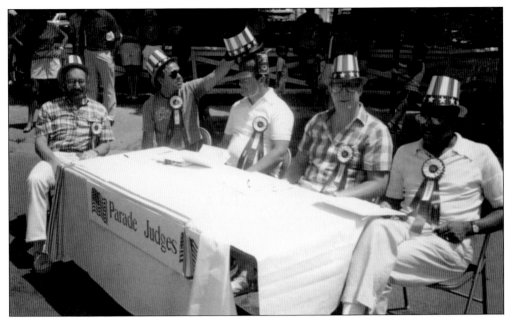

On the morning of July 4, 1985, festivities began with a bicycle race in the park. In the afternoon, a parade started at Kilgour Elementary, led by Cincinnati Reds catcher Johnny Bench, followed by music and fireworks. From left to right, Norm Miller, Jim "Squirrel" Stadtmiller, Ed Bracke, Pat Barry, and Nathaniel Jones volunteered as parade judges. (Courtesy of Cincinnati Parks Library and Archives.)

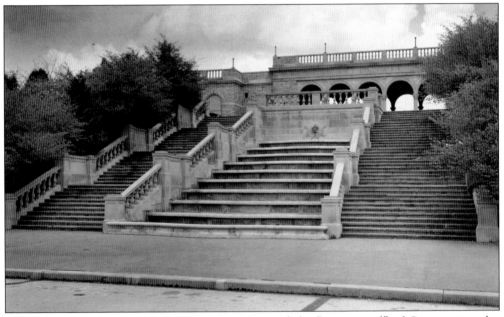

Although Ault Park is not the largest, it is nicknamed the "crown jewel" of Cincinnati parks. Here, the pavilion has been restored to its original glory in about 1988. The front facade now faces the Smittie Concert Green in honor of George "Smittie" Smith, the former music director at Withrow High School, who performed with his band at Ault Park for 50 years. (Courtesy of Cincinnati Parks Library and Archives.)

Five
ALMS PARK

Frederick H. Alms Memorial Park, commonly referred to simply as Alms Park, was established in 1916. The land was gifted to the city by Eleanora C.U. Alms in honor of her late husband. Similar to Ault Park, the pavilion was not built right away. This image from 1928 shows the site where the pavilion was to be built the following year. (Courtesy of Cincinnati Parks Library and Archives.)

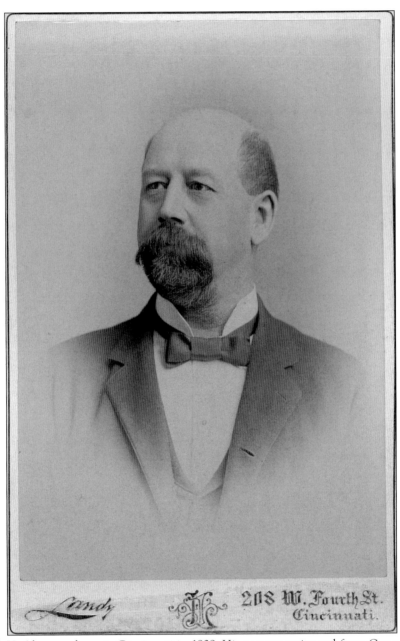

Frederick H. Alms was born in Cincinnati in 1839. His parents emigrated from Germany. After joining the Union army during the Civil War, he returned to Cincinnati and, with his brother William Alms and his cousin William Doepke, founded a dry goods store downtown called Alms and Doepke. The store's success rivaled that of Shillito's. Although the store closed in 1955, the palatial building still stands on Central Parkway; the offices of Hamilton County Jobs and Family Services are housed there today. Alms also opened a successful hotel in Walnut Hills. He died in 1898. In 1916, Frederick's wife, Eleanora, gifted land to the city for the development of Alms Park. When Eleanora C.U. Alms died in 1921, she left most of her estate of $1.5 million in a trust to be spent on public benefits. That amount is equivalent to nearly $28 million in 2024. (Courtesy of the Cincinnati & Hamilton County Public Library.)

Mt. Lookout borders Alms Park, allowing residents to easily enjoy its close proximity. When Nicholas Longworth (1783–1863) first purchased this tract of land, he started a vineyard and became a maker of Catawba wine. The remnants of a wine cellar are still there, shown in 1931. (Courtesy of Cincinnati Parks Library and Archives.)

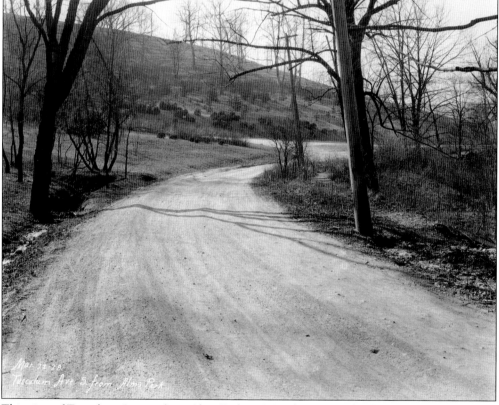

This view of Tusculum Avenue from Alms Park in 1928 shows a rural hillside in the background. The park sits atop Mt. Tusculum, which used to be called Bald Hill. It was given that name because Shawnee tribes cleared trees to have an unimpeded view of white men as they settled the area known as Columbia in the late 1700s. (Courtesy of Archives and Rare Books Library, University of Cincinnati.)

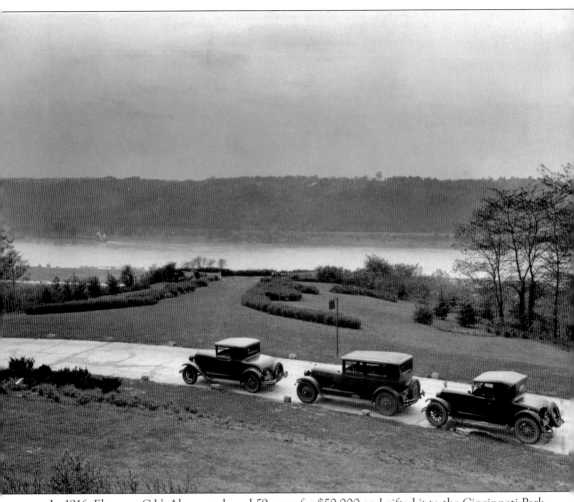

In 1916, Eleanora C.U. Alms purchased 59 acres for $50,000 and gifted it to the Cincinnati Park Board. At this point, there were not many homes on the property. One residence was that of William Henry Venable, a teacher at Walnut Hills High School. In 1872, he wrote *Venable's School History of the United States*, which was used in Ohio schools for many years. Before her death in 1921, Alms amended her will to bequeath an additional $60,000 for the purchase of another 60 acres. However, by the time the funds were made available, the board could only afford to buy 23 acres due to rising real estate prices. The current size of Alms Park is 94 acres. Taken in 1929, this photograph shows where the overlook pergola now stands. It is a popular spot for visitors to sit and take in the views of the rivers, Lunken Airport, and the Kentucky hillside. (Courtesy of Cincinnati Parks Library and Archives.)

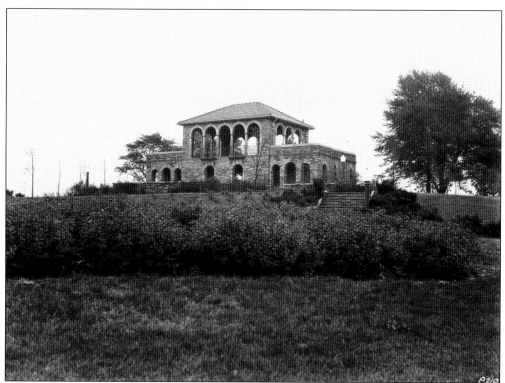

Similar to that of Ault Park, the pavilion of Alms Park boasts Italian Renaissance architecture and design. With less than 100 acres, however, it is a considerably smaller park. Shown here when it was completed in 1929, the building was constructed of Bedford stone. Although the land was donated by Eleanora C.U. Alms, she did not live to see the pavilion built. (Courtesy of Cincinnati Parks Library and Archives.)

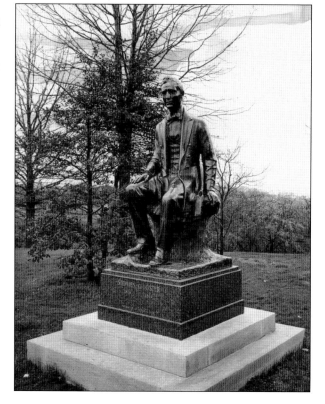

This statue of Stephen Collins Foster was sculpted by Arthur Ivone (1895–1974). He is most well-known for his bronze statue *The Doughboy* (often referred to as the Ohio World War Memorial). Foster wrote "My Old Kentucky Home" in the 1850s. The statue was first unveiled at Music Hall before Josiah K. Lilly donated it to Alms Park in 1937. (Courtesy of Cincinnati Parks Library and Archives.)

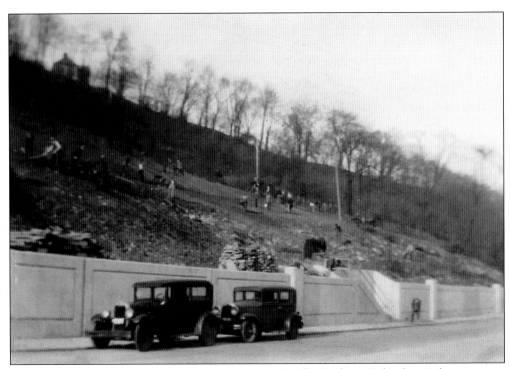

In the image above, trees were planted on the park's hillside along Columbia Parkway as part of the Public Works Administration in 1934. Farther to the east, when it was first built, the westbound lanes of Columbia Parkway could be accessed from Tusculum Avenue; it has since been closed off. The picture below was taken in 1944 as men planted a single tree near the lookout. Note the guardrail and fence. Elevated 300 feet above Lunken Airport, Alms Park was an ideal spot for people to come and observe the excitement of early aviation. From this vantage point, the convergence of the Ohio River and the Little Miami River is also visible. (Both, courtesy of Cincinnati Parks Library and Archives.)

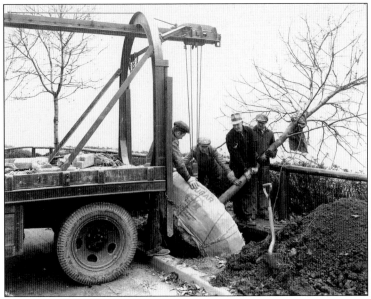

Six
TRAGEDY STRIKES

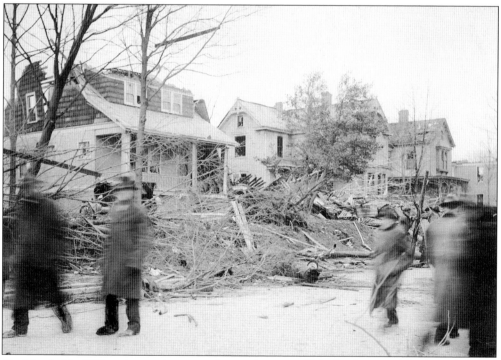

On March 11, 1917, a devastating tornado struck parts of Mt. Lookout and Hyde Park. Many homes suffered severe damage or total destruction. On the far left, 1305 Grace Avenue lost its roof. The other two homes are 1315 and 1317 Grace Avenue. Impressively, the three homes in this photograph remain firmly planted where they were constructed over 100 years ago. (Courtesy of Tom Compton.)

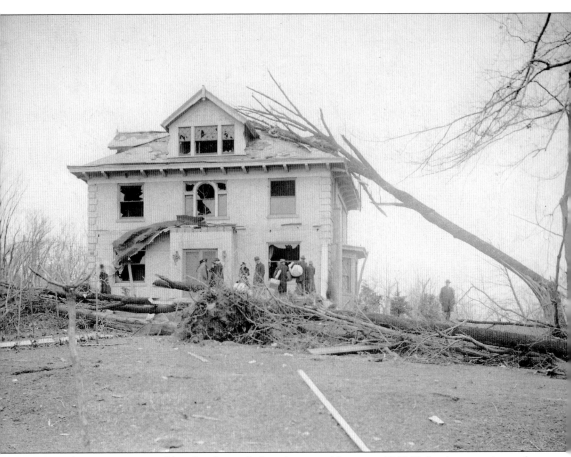

Frank M. Zumstein and his family resided in this grand home at 1312 Delta Avenue, situated at the intersection of Griest Avenue. Entire trees were uprooted. According to records, Zumstein's was one of only two homes that had tornado insurance. He purchased the property in 1913 from the Goelitz family, who were known for their candy corn company. The home survived the tornado and was repaired, but it was demolished a few years after Zumstein died in 1924. A new building was constructed and has since been used by the Cincinnati Bell Telephone Company. In the 1860s, Zumstein, who was born in Germany and moved to the United States at the age of 17, began the first taxi service downtown. People could rent a horse and cab for a fare. Later, his company transitioned to motor vehicle cabs. His brother, postmaster John Zumstein, is the namesake of Zumstein Avenue in Hyde Park. (Courtesy of Tom Compton.)

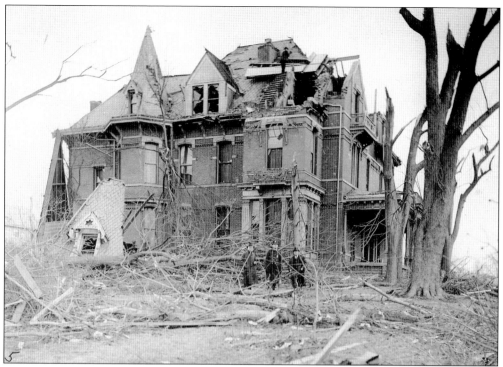

Pictured above is what was once the residence of Charles B. Kessing at 2880 Linwood Avenue, which newspaper articles described as one of the grandest homes in the area. It had been previously owned by Col. William B. Smith (a local legend known as "Policy Bill" due to his influence in politics at the time). It was Smith who named Monteith Avenue when the road was built alongside his property. Kessing was the founder of C.B. Kessing and Sons Company, which specialized in dry goods. He and his wife, Emma, had nine children. In the image below, Kessing is pictured standing next to his vehicle, which was thrown onto a neighbor's property. (Both, courtesy of Tom Compton.)

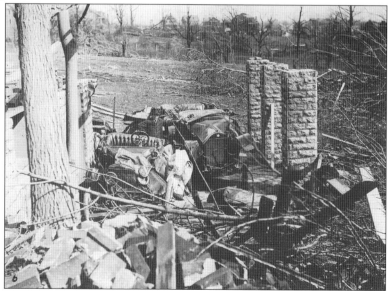

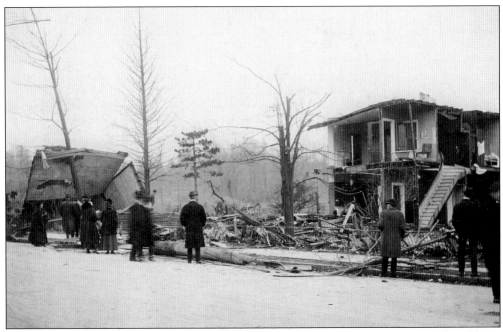

The home of Henry K. Gibson at 2881 Linwood Avenue no longer exists, nor does the address. It stood roughly where the Cincinnati Metropolitan Housing apartments were built in the 1960s. This photograph was taken facing southeast on Linwood Avenue, between the intersecting streets of Monteith Avenue and Cryer Avenue. Gibson was an attorney and president of the Hyde Park Business Club. (Courtesy of Tom Compton.)

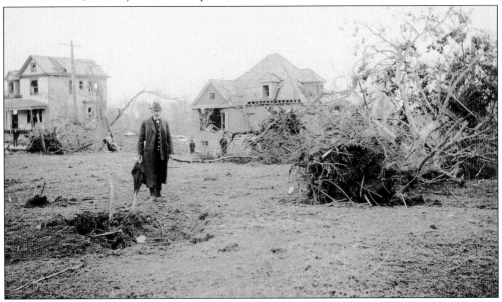

This image was taken approximately from where Kilgour Elementary now stands. In 1917, the school had not yet been built. The home on the right is 1354 Herschel Avenue, built in 1907. It is still standing today. On the left is 1360 Herschel Avenue, also still standing. Today, the front facade looks different than shown here, but other features of the original house are recognizable. (Courtesy of Tom Compton.)

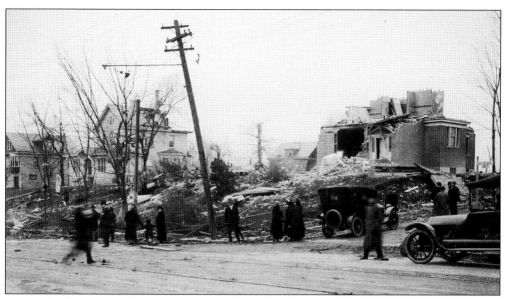

Mary Scheidemantle was thrown from the second story of her home at 1323 Delta Avenue (far right). She was found unconscious, but she survived. Following the tornado's destruction, instead of being torn down, the house was rebuilt using the same foundation and frame. The house still stands on the corner of Delta Avenue and Springer Avenue. The other homes in this image remain standing as well. (Courtesy of Tom Compton.)

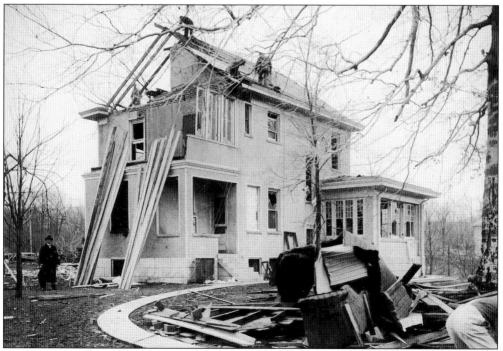

The property at 1311 Delta Avenue was the home of William F. Groene. He was hired at R.K. LeBlond Machine Tool Company as a teenager in the 1890s and went on to become vice president of the company. He had over 120 patents issued to him. This photograph was taken in the backyard of the property. The house is still standing today. (Courtesy of Tom Compton.)

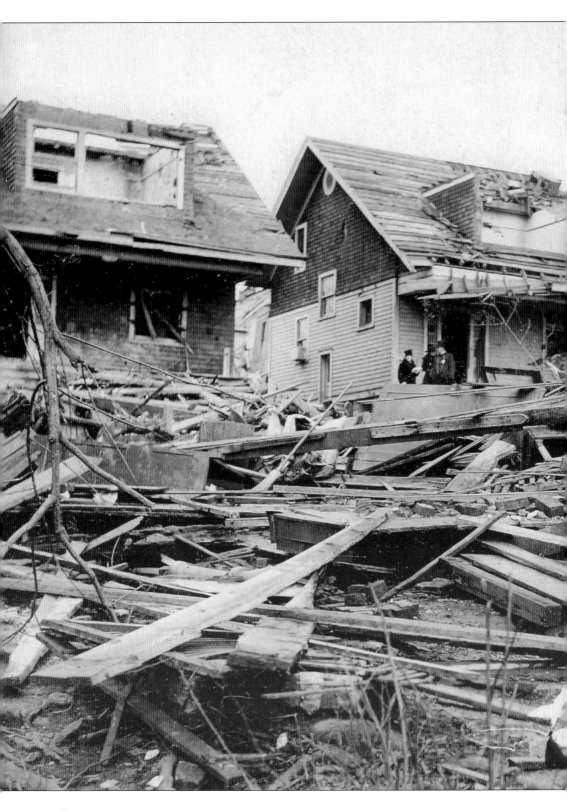

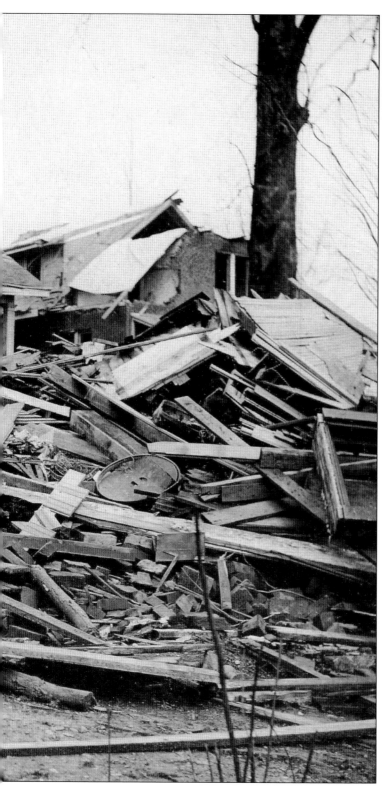

The main streets that were impacted by the 1917 tornado included Delta, Observatory, Grace, Herschel, Griest, Halpin, and Linwood Avenues. Winds reached 75 miles per hour and caused three deaths: Matthew McCarty, 3 years old; John Nelson, 80 years old; and Omer (Ohmer) T. Glenn, 82 years old. Glenn's home on Grace Avenue, at the forefront of this image, was completely destroyed. His body was discovered in the rubble. Glenn was described as a reclusive man who was afraid of electricity and preferred to light his home with candles. It was also rumored that he had thousands of dollars hidden in his home. As a result, while the wreckage was being cleared, patrolmen were posted around his property to deter looters. A few days after Glenn's death, the *Cincinnati Enquirer* printed details about his will, in which he left behind an estate worth $250,000—equivalent to roughly $6 million in 2024. (Courtesy of Tom Compton.)

Every community experiences tragedies. Sometimes, it takes the form of a natural disaster, such as a tornado. Other times, it is something unthinkable. In the early morning of October 23, 1969, Martin Dumler II, 29 years old; his wife, Pat Wilson Dumler, 27 years old; and her mother, Mary Wilson, 50 years old, were found shot and stabbed to death at 1192 Beverly Hill Drive. The Dumlers had two children, Martin III and Jean, 5 and 4 years old, respectively. When the children woke, they could not get into their parents' bedroom, so they went to a neighbor's house to get help. It was around that time the Dumlers' maid, Ruby Boehner, arrived and found the back door open. She discovered the bodies and called the police. Police were perplexed by the lack of evidence and motive. Robbery was ruled out, as the women were found wearing jewelry, and there was money sitting on the dresser. No arrest was ever made. More than 50 years later, this case remains unsolved today. (Courtesy of the author.)

Seven
THE HEART OF THE TOWN

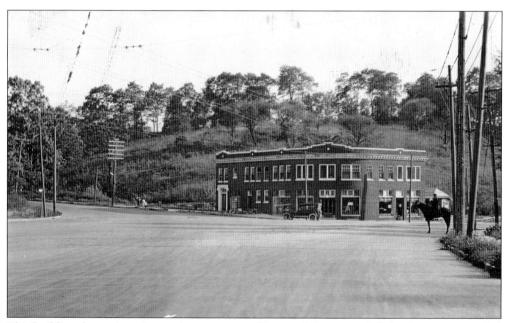

This building, located on the southwest corner of Linwood Avenue and Delta Avenue, was called Rutterer's Corner. Edward Rutterer opened one of the first businesses in Mt. Lookout Square. He lived in one of the apartments above until his death in 1938. This photograph is dated 1916, shortly after the building was completed. Mt. Lookout Tavern was built to the left in 1921. (Courtesy of Sharon Stanton.)

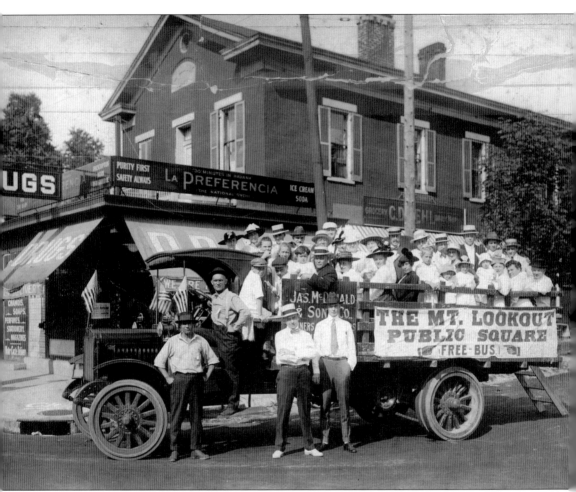

In this c. 1916 picture, men and women have boarded a free bus in front of Abner Curtis's drugstore at the northern intersection of Delta Avenue and Linwood Avenue, where the United Dairy Farmers gas pumps are located today. Constructed in 1874, this building was known as Fehl's Corner. C.D. Fehl purchased the building in 1907 and opened a small grocery store. He also ran a post office branch for a period of time. Similar to Edward Rutterer on the opposite end of the square, Fehl lived in an apartment upstairs from his store. By 1937, Bob Spencer wrote in the *Cincinnati Post*, "Mt. Lookout is now one of the largest shopping centers in eastern Cincinnati. There are three drugstores, three chain groceries, three dry-cleaning establishments, four beauty shops, two barber shops, three gas stations, a bakery, a hardware store, a plumbing shop, and a dry goods store." (Courtesy of the General Photographic Collection–Suburbs [SC#59], Cincinnati Museum Center.)

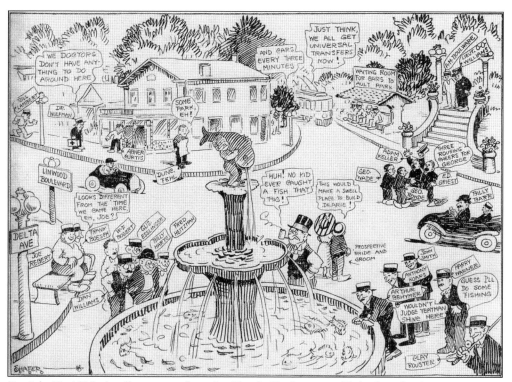

On July 12, 1916, the illustration above by Claude Shafer was published in the *Cincinnati Post* to announce the grand opening of "Mount Lookout Public Square," as it was called then. The image depicts a large fountain (similar to that of Hyde Park Square) that was never built. Below, some of the original members of the Mt. Lookout Community Council pose in 1921. The organization had a role in installing traffic lights on Delta Avenue, and it helped plan the dedication of the pavilion at Ault Park in 1930. Its newspaper publication, the *Mt. Lookout Observer*, was first printed in 1926. (Above, courtesy of the *Cincinnati Post* Collection, Cincinnati Museum Center; below, courtesy of the Mt. Lookout Community Council.)

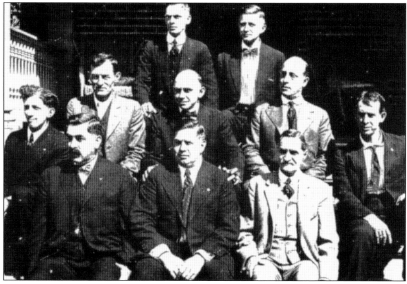

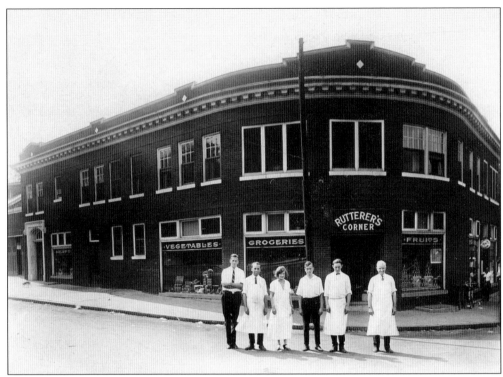

Edward Rutterer opened his first grocery store at 3411 Eastern Avenue in 1873. In 1916, just in time for the grand opening of Mt. Lookout Square, he established a new store on the southwest corner. The address at the time was 3205 Linwood Avenue. The building would eventually be torn down to create a parking lot next to Chase Bank. Above, Rutterer is pictured (third from right) in 1926. His grocery was one of the first businesses to open in the square. Later, businesses like Lindner's ice cream shop and Birk's Bakery leased space in this building. Pictured below is the house that originally stood where Rutterer's building was constructed. (Both, courtesy of Sharon Stanton.)

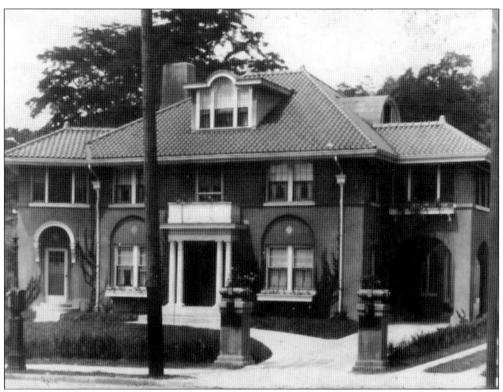

Above, Rohde Funeral Home, built in 1920, is the longest-running business in Mt. Lookout Square. Located at 3183 Linwood Avenue, it has always been a family business. Below, Donald H. Karcher opened Zip's Café in 1926 at 1036 Delta Avenue. The only other diner at that time was Mt. Lookout Grill (later renamed Mt. Lookout Tavern). When Zip's first opened, women were not permitted in the back bar, called the Code Room, where men placed bets on horses. By 1940, the Blue Dell hamburger joint opened a few doors down at 1028 Delta Avenue, offering some competition. Since Karcher, Zip's Café has maintained loyal customers under the proprietorship of Harold Stumpf, John Berger, Ron Bircher, Brian Murrie, and Mike Burke, the present owner. (Above, courtesy of Geo. H. Rohde & Sons Funeral Home; below, courtesy of the author.)

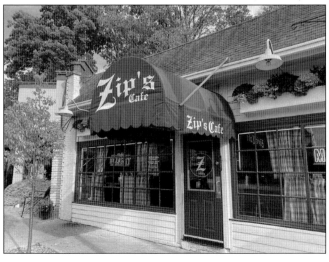

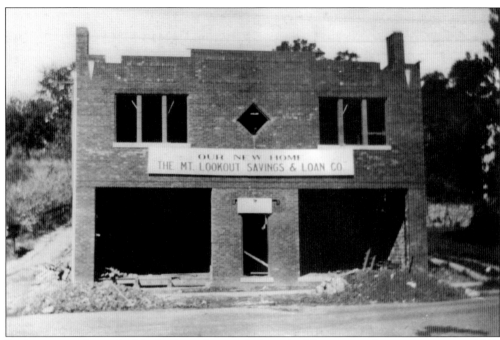

In the picture above, the Mt. Lookout Savings & Loan building was under construction in 1921. The address is 3165 Linwood Avenue. The image below is the same building in 1959. At that time, the president of the company was Simon Nielson, and William Judd was vice president. Judd also owned Judd's Service Station (now Jiffy Lube) next door at 3151 Linwood Avenue. In the 1970s, Birk's Bakery leased the Mt. Lookout Savings & Loan building after moving from the Rutterer building at 3205 Linwood Avenue. Currently, the retailers are Mt. Lookout Smoke Shop (on the left side) and ADash Beauty Studio. The original bank vault is still anchored inside. (Both, courtesy of Michael Makin.)

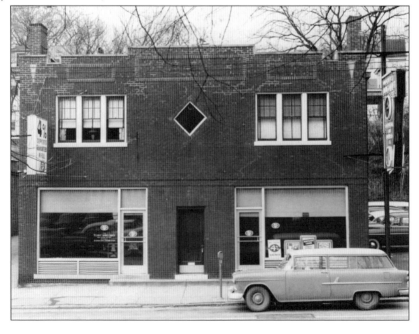

In 1909, Edwin Griest was the founder and first president of the Mt. Lookout Savings & Loan Company. The company moved from its original building, 3165 Linwood Avenue, to 822 Delta Avenue, which later became Albers grocery market. Griest resided at 3251 Observatory Avenue. He died in 1942. (Courtesy of the *Cincinnati Post* Collection, Cincinnati Museum Center.)

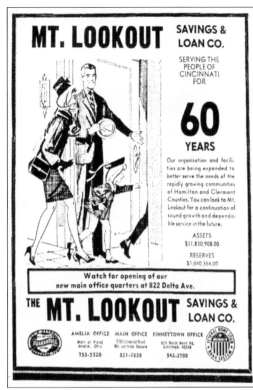

Today, Delwood is a popular restaurant where friends and families gather for drinks and dinner. This building, at 3200 Linwood Avenue, has been occupied by a number of businesses, including Hein's Pharmacy, which was open for several decades beginning in 1936. Before that, in 1926, the parish of Our Lord Christ the King held its very first mass in this building before its church was completed. (Courtesy of the author.)

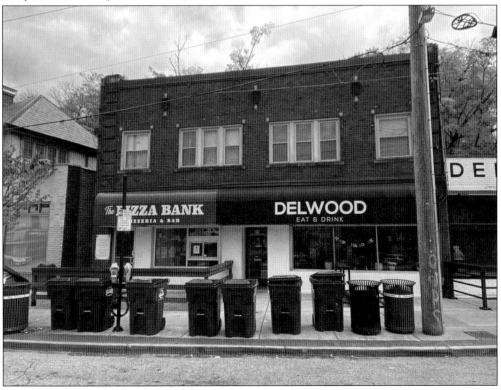

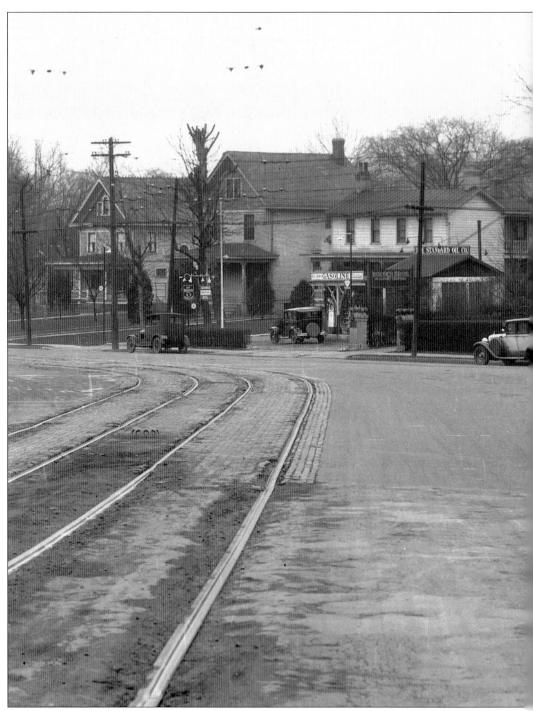

This photograph was taken in 1931 facing south on Delta Avenue approaching Mt. Lookout Square. Linwood Avenue is seen to the right, where a young woman carrying books is waiting by the stop sign. Behind her is the Geo. H. Rohde & Sons Funeral Home, completed in 1920. To the left of the funeral home is the Boesch Bros. roofing company, an oil station that sold Red Crown gasoline, and a residential home, all of which were owned by Frank Boesch. These buildings were

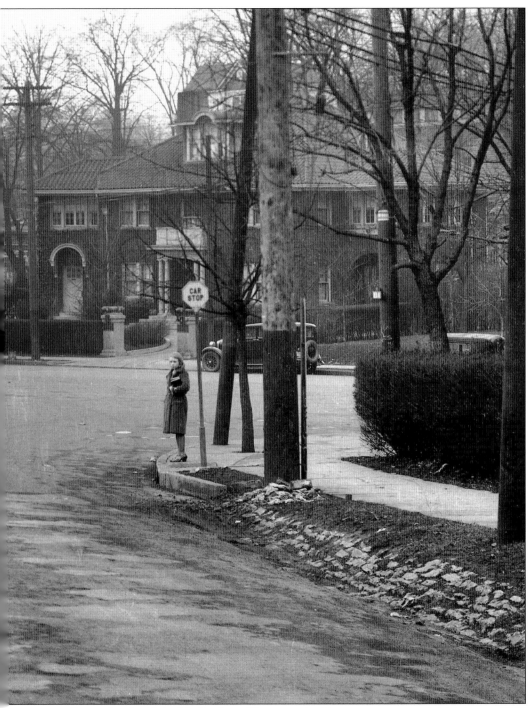

eventually razed to build the Mt. Lookout Theater and a Kroger grocery store (which is now CVS) with a bowling alley in the basement. The house on the far left, also owned by Boesch, is at 3199 Linwood Avenue. It was built in 1907 and is still standing; Stereo ADV has been in business there since the 1980s. The city was in the process of making road improvements when this image was captured. (Courtesy of Archives and Rare Books Library, University of Cincinnati.)

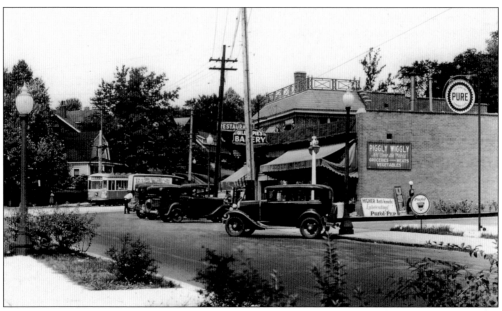

This picture from 1933 shows northbound Delta Avenue on the eastern side of Mt. Lookout Square. Gillespie Bakery had just recently become a new addition to the square. Located at 1022 Delta Avenue in the current Ichiban building, it was run by brothers Herb and Fred Gillespie. Next door was a Piggly Wiggly grocery store. (Courtesy of Phil Lind.)

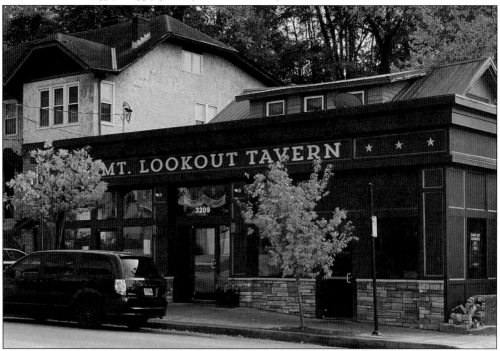

Mt. Lookout Tavern, located at 3209 Linwood Avenue, was established in 1921. At first, it was called Mt. Lookout Grill. One of the early owners and operators was Norma Stevenson. The 1953 menu offered filet mignon for $1.85, including fries, cole slaw, and buttered rolls. (Courtesy of Stevi Turecky.)

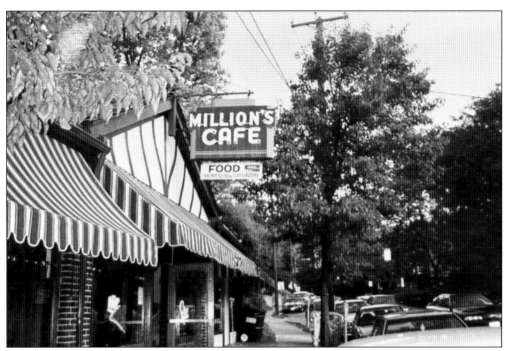

Million's Café, located at 3210 Linwood Avenue, has been open since 1945. Before that, it was Joe Humphrey's Café. There have been some changes since the 1980s, when the above photograph was taken, but the original sign still hangs above the door. The first proprietors of Million's Café were Bob and Dorsey "Dot" Million. They transferred the business to their nephew Harold Patrick (shown below in the 1970s), who became known affectionately as "Pat Million." In 1958, he became president of the Mt. Lookout Community Council, and in 1974, he was named Citizen of the Year. His wife Pauline "Polly" was in charge of bookkeeping and preparing lunch orders. They owned the bar until 1979. Million's Café was the only bar in the square to offer Hudepohl beer on tap. (Above, courtesy of Stevi Turecky; below, courtesy of Laurie Clark.)

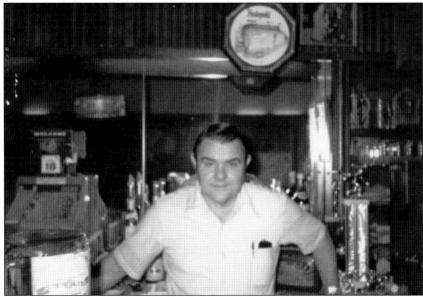

Frank Boesch, his daughter Frances Boesch Faber, and her husband, Cecil Faber, are pictured above around the 1950s. In the early 1900s, Boesch bought and developed several acres of land in the square. In 1940, the Mt. Lookout Theater (below) was built on Boesch's property, replacing a service station. The theater was designed by architect George H. Godley, who also served as the second editor of the *Mt. Lookout Observer*. Jerome M. Jackson was the theater's manager. Following Boesch's death, the Fabers continued to manage his properties. After 40 years, the theater closed and reopened briefly as Del Frisco's Restaurant, and later the Cinema Grill, which combined a movie theater experience with dining tables and booths. Since 2008, the building has been home to the Redmoor Event Center. (Above, courtesy of Debbie Wessel; below, courtesy of the Hamilton County Auditor.)

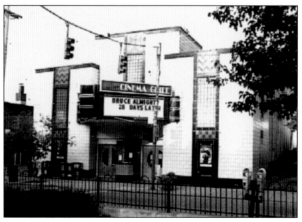

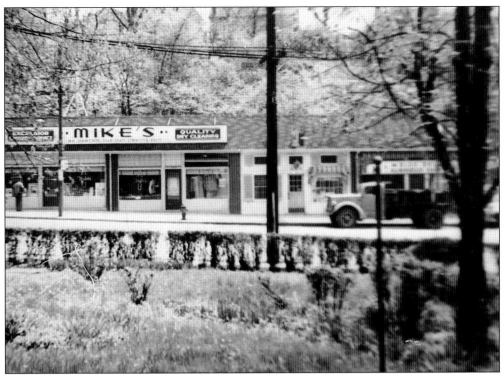

In business for about 30 years, Mike's Dry Cleaners was located at 1032 Delta Avenue. Zip's Café is to the left, just out of the picture. In the early 1970s, the Boardwalk Hobby Shop took this spot. (Courtesy of Geo. H. Rohde & Sons Funeral Home.)

Mildred Frazier opened her salon in 1945 on the second floor of 3197 Linwood Avenue. At that time, Kroger occupied the first-floor space. In 1968, Frazier purchased a shop north of Zip's Café at 1038 Delta Avenue and relocated her business there. Since the 1990s, Tracey Bender has been running her salon, Total Eclipse, at this spot. (Courtesy of the Mt. Lookout Community Council.)

Mildred Frazier

Beauty Salon

Mt. Lookout Square

Since 1945

Open Evenings by Appointment

321-6571

**New Location
1038 Delta Avenue**

*Permanent Waving
Blonding & Tinting
Hair Cutting
Our Specialty
Hair Styling*

*Wigs! Sales
Cleaned & Styled*

Manicuring

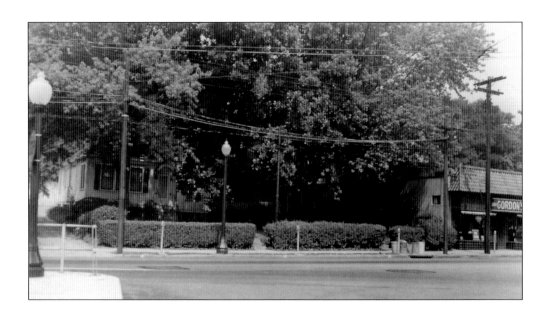

The image above of Gordon's Cocktail Lounge (far right) is from 1950. The address was 3175 Linwood Avenue. It later became Murphy's Pharmacy (below) and then Spreen Pharmacy. The building has since been remodeled and repurposed; today, it is the northern section of the Animal Hospital on Mt. Lookout Square. Lou Grupenhoff of 712 Glenshire Avenue was the owner and pharmacist at Murphy's for many years. He was honored as Mt. Lookout's Citizen of the Year in 1984. Both houses to the left of Gordon's were torn down to build the animal hospital and the building that holds Nailtique and Lookout Joe's coffee shop. (Above, courtesy of Geo. H. Rohde & Sons Funeral Home; below, courtesy of the Mt. Lookout Community Council.)

LIFE — FIRE — CASUALTY — BONDS — A&H

Phone 621-0511

MURPHY PHARMACY

MT. LOOKOUT'S ONLY
MAXIMUM SERVICE PHARMACY
EMERGENCY PRESCRIPTION SERVICE

FREE DELIVERY CHARGE ACCOUNTS
PROMPT, FRIENDLY ATTENTION HONEST VALUE

Phones — 321-3910 321-3911

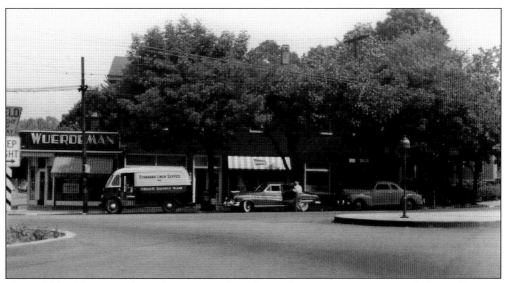

The Fehl building sat where the UDF parking lot and gas pumps are currently located in Mt. Lookout Square. The Fenton Wuerdeman Thayer Dry Cleaning Company had several locations in Cincinnati, one of which was in the square. The store to the right was Charm Classics, a clothing shop that was known for putting on fashion shows. (Courtesy of Geo. H. Rohde & Sons Funeral Home.)

This advertisement from 1970 included the names of the new owners of Charm Classics, Marge and Jim Behr. The company began under the ownership of Louis and Margaret Henkel in the 1950s. Before moving to 1026 Delta Avenue, it was located across the street in the Fehl building. (Courtesy of the Mt. Lookout Community Council.)

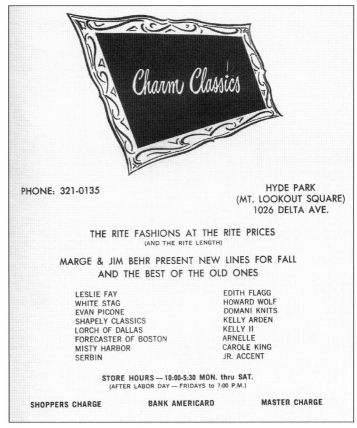

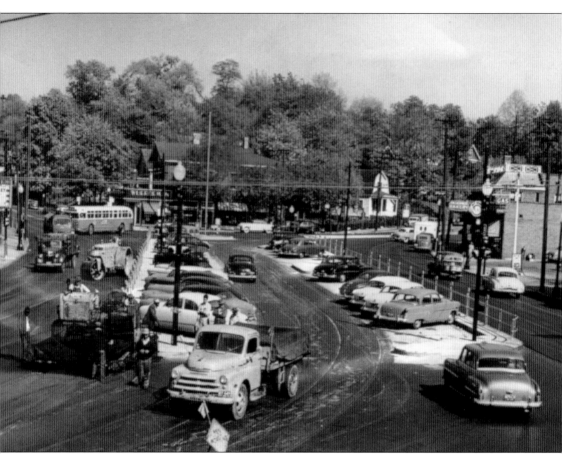

The Mt. Lookout Community Council proposed the new design of Mt. Lookout Square. After streetcar operations came to an end in 1951, it was the organization's desire to make better use of the space. This image is dated 1952; the tracks had not been removed or covered yet. At first, the community's reactions to the new traffic pattern were mixed. One improvement was that pedestrians could cross intersections more safely and easily. One disadvantage was that angled parking spots along the streets were replaced by parallel parking spots. Business and shop owners along Delta Avenue and Linwood Avenue complained that their customers were less inclined to parallel park. On the far left, the Mt. Lookout Theater, which was built in 1940, was showing *What Price Glory* featuring Dan Dailey. (Courtesy of Alan Kain/*Cincinnati Enquirer*/USA TODAY Network.)

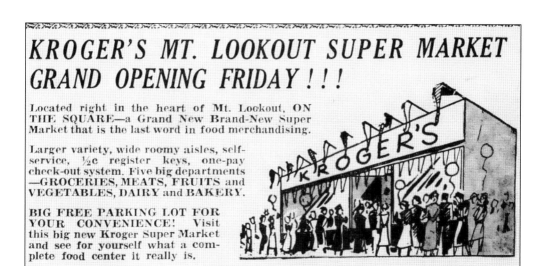

Above, the *Cincinnati Post* ran this advertisement on December 11, 1941, when Kroger opened at 3197 Linwood Avenue (presently occupied by CVS). The building had just been constructed by Frank Boesch. Mt. Lookout Lanes was located in the basement. Below, drivers could access a service station at 1018 Delta Avenue. Owned by Omar Grayson, it was situated north of the stairs to Lookout Circle. In 1986, the service station was demolished to construct the Mt. Lookout Professional Building, which has been home to a number of businesses, including P-Body's, Prime Time Video, Subway, and Cloud 9 Sushi. A sign for Walt's Hobby Shop, which opened in 1953, hangs above the entrance to the store. Paul Burton ran his business until 1973. (Above, courtesy of the Kroger Co.; below, courtesy of Geo. H. Rohde & Sons Funeral Home.)

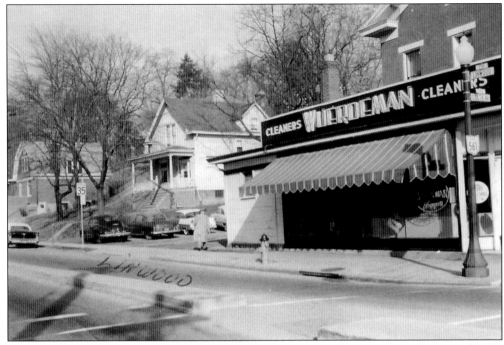

In the 1960s, Allene Kirschner ran a beauty salon at 3156 Linwood Avenue (far left). Around 1955, the center house and Wuerdeman's Cleaners were demolished to build a Shell station, which is now United Dairy Farmers. Two new buildings were constructed at 3162 and 3166 Linwood Avenue, where Lin-Del Pony Keg, Mt. Lookout Beverage, Figaro's, Ruthai's, and Ramundo's Pizzeria have done business. (Courtesy of Geo. H. Rohde & Sons Funeral Home.)

Ed Bracke Sr. stands in front of his grocery store, Bracke's Meats and Produce. The store, which opened in 1950, was situated directly south of the stairs leading up to Lookout Circle and Lookout Drive. Residents could easily walk down to the square to purchase some groceries. When Bracke's age and health prevented him from working, his son Ed Bracke Jr. assumed responsibility for the business. (Courtesy of Helen Bracke.)

A young Ed Bracke Jr. (1936–2017) poses with a sales representative in front of a cheese display at Bracke's Meats and Produce, 1010 Delta Avenue. In 1975, he was named Mt. Lookout's Citizen of the Year. He was also elected president of the Mt. Lookout Community Council. He advocated for repairing the Grandin Road Bridge because he feared an increase in traffic jams in the square. (Courtesy of Helen Bracke.)

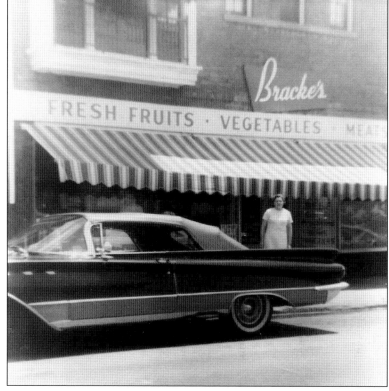

For 53 years, Bracke's Meats and Produce was a cherished fixture in the Martin Building. Prior to that, this space held a Kroger store and a Hollywood Market. In this c. 1950s image, Ed Bracke Sr.'s wife, Mary Holman Bracke, stands next to her car in front of the store. (Courtesy of Helen Bracke.)

BONELESS POT ROAST	Lb. 2.29
EXTRA LEAN BEEF STEW	Lb. 2.99
BRACKE'S HOMEMADE ITALIAN SAUSAGE	Lb. 2.49
CASE SLICED AMERICAN CHEESE	Lb. 2.69
TINY LINK SAUSAGE	Lb. 2.39
CASE SLICED BACON	Lb. 1.69
FRESH HEAD LETTUCE	Ea. .79
FRESH BANANAS	Lb. .29
PINK GRAPEFRUIT	3 For .89
CALIFORNIA CARROTS	Bag .29

STOUFFERS LEAN CUISINE SALE
ZUCHINI LASAGNA	1.39
CHICKEN CHOW MEIN	1.39
SPAGHETTI & MEAT	1.39
CHEESE CANNELLONI	1.39
SAGA CHEESE	Lb. 5.49
DOFINO CHEESE	Lb. 3.99
LE MENU CHICKEN ALA KING	2.99
LE MENU HAM STEAK	2.79

BRACKE'S INC.
1010 DELTA AVE.
"ON THE SQUARE"
MT. LOOKOUT — 871-1515

FINER MEATS AND FRESH PRODUCE
"PHONE IN" YOUR ORDER — IT WILL BE READY WHEN YOU CALL FOR IT.
SPECIALS GOOD THRU JANUARY 25, 1986

Bracke's grocery store offered several homemade recipes, including its beef stew, as shown in this 1986 advertisement from the *Mt. Lookout Observer*. After taking over the family business full-time for three decades, Bracke and his wife, Helen Heitker Bracke, decided to retire in 2003. Today, Mt. Lookout Television and Electronics is located here. (Courtesy of the Mt. Lookout Community Council.)

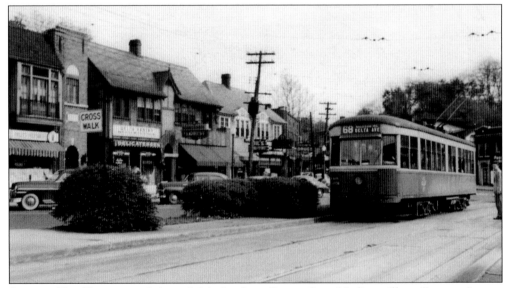

Streetcar No. 68 was routed through Mt. Lookout Square from Madisonville to Eastern Avenue and back. In the background, the sign for Rennebarth Florist hangs over the door where Vin Acco Time Repair is today. Arnold and Jean Rennebarth operated the shop from 1935 to 1964. The store was later run by Vee Goodwin. This picture is from 1955. (Courtesy of Phil Lind.)

Dr. Jerome Janson and his wife, Betty, are caught in a candid moment around the 1980s, offering a glimpse into their personal lives. For over 25 years, Janson ran his physician's office in Mt. Lookout Square at 3215 Linwood Avenue. He retired and closed his office in 1987. His contributions were noticed by 1968, when he was recognized as Citizen of the Year by the Mt. Lookout Community Council. Janson also gave 25 years of service to Xavier University, where he was a physician to the athletic teams. Janson was born into an entrepreneurial family who founded a local company in the "fancy food" market. Under the supervision of his father, Nicholas J. Janson of 814 Tweed Avenue, the Janson Company was the first to offer canned dog food and frozen orange juice in Cincinnati. (Courtesy of Ellen Renneker.)

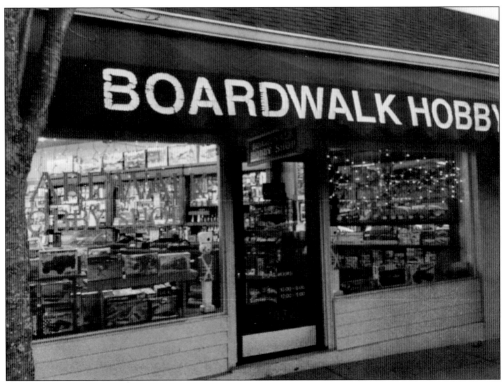

The Boardwalk Hobby Shop took up retail space in what had previously been Mike's Dry Cleaners, 1032 Delta Avenue. A local treasure for game enthusiasts, Boardwalk was owned and operated from 1972 to 2020 by Mike and Marilyn Shore. The store was the first in the city to sell Dungeons & Dragons game sets, according to a *Cincinnati Post* article dated September 6, 1979. (Courtesy of Mike Shore.)

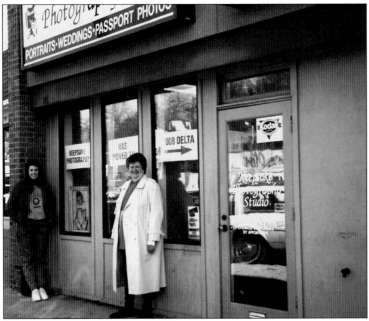

Kim Kolthoff Rice, the owner and operator of Keepsake Photography, is pictured here with her assistant Sue Rinehart at 1018 Linwood Avenue. The posters in the windows indicate that her business was moving to 1008 Linwood Avenue, which is where it is still located today. Rice's business has been open in Mt. Lookout Square since 1988. (Courtesy of Kim Kolthoff Rice.)

Eight
Schools and Churches

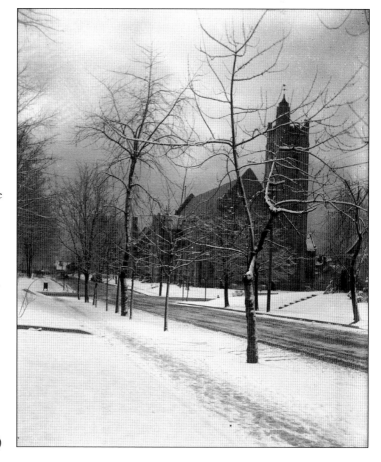

Today, the church on the corner of Observatory Avenue and Grace Avenue is called the Hyde Park Community United Methodist Church, but the original building that stood here in 1880 was called the Mt. Lookout Methodist Episcopal Church. It was made of wood and suffered damage during the 1917 tornado. The church in this picture was erected in 1927. (Courtesy of the Cincinnati Observatory.)

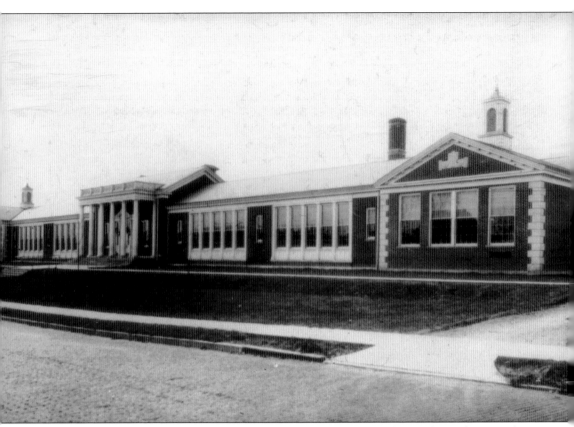

When the Hyde Park School was completed in 1900, it was not long before the student population outgrew its space. As a solution, the Cincinnati Board of Education built a two-room colony school on Delta Avenue across from Niles Street. Though small, it allowed some Mt. Lookout children to attend a school that was much closer to their homes. After John Kilgour's death, his wife, Mary, gifted land on Herschel Avenue for a proper school to be built. However, even after the John Kilgour Public School opened in 1922, it remained a colony school under the supervision of the Hyde Park School. At the time, Ellen Andrew was a teacher at Kilgour, but she was also the acting principal. Hyde Park's principal visited the Kilgour school to check on students and to disburse paychecks to teachers. Within five years, additions were completed to accommodate the growing enrollment. Kilgour became its own neighborhood school, and Andrew was officially named the building principal. She retired in 1943. This photograph is dated 1928. (Courtesy of the Cincinnati & Hamilton County Public Library.)

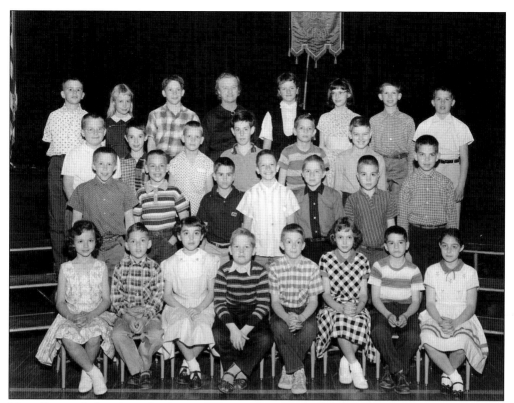

Mary Bennett's fourth-grade class at Kilgour Elementary is pictured above in 1959. Bennett, who taught in room 13, is standing in the fourth row, fourth from left. She was known for taking trips abroad and giving illustrated presentations to parents and her students upon her return; some of her travels included India and Africa. She taught for 45 years, 40 of which were at Kilgour Elementary. Bennett passed away in 1989 at the age of 89. The image below is a student's "Schoolday Memories" card to accompany his class picture. This one is dated April 30 of the 1958–1959 school year. It is interesting to note that of the 28 students in Bennett's class this year, there were only seven girls. (Both, courtesy of Kilgour Elementary.)

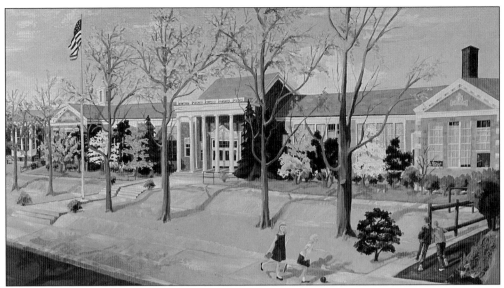

John F. Stevenson (1927–2019) painted this canvas of Kilgour Elementary in 1967. He was a teacher there for 25 years. He also wrote a short history about the school. After retiring from teaching, he volunteered as a docent at the Taft Museum for over 15 years. His life partner was George Maurer. (Courtesy of Kilgour Elementary.)

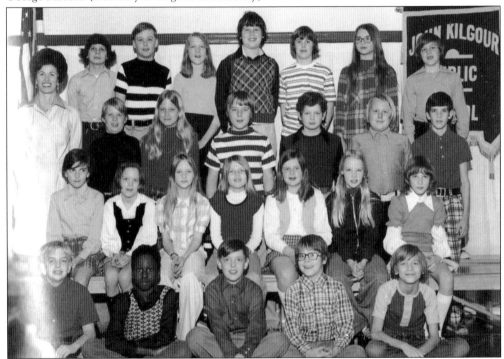

Jean Kareth is standing on the far left with her fifth-grade students in 1973. Kareth taught math for many years, and she was also an instructor at the University of Cincinnati. She has been described as a "demanding but fantastic" teacher. In 1965, she started weekly telecasts on WLWT to help students with their math homework. It was called *Modern Math: Magic or Mystery?* (Courtesy of Kilgour Elementary.)

Chester R. Heery is pictured here with students Stephanie Black Hughes and Eric Duff in 1964. Heery started teaching in the 1920s. He paused his career in education to serve in World War II. He was the principal at Kilgour Elementary for 22 years, retiring in 1968. In 1989, Heery died at the age of 81. (Courtesy of Stephanie Black Hughes.)

In August 1993, the movie *Milk Money* began filming on location in Mt. Lookout. Certain scenes were filmed at Kilgour Elementary, including room 22 (shown here), and some students were selected as extras in the movie. The exterior of the school was also used in the film, although the name on the front of the building was changed to Owen Meany Junior High. (Courtesy of Kilgour Elementary.)

Fr. Edward J. Quinn was ordained in Rome in 1916. During World War I, he was sent to France to serve as chaplain of the 59th Infantry Division, and later, he served in the 107th Cavalry of the Ohio National Guard. Quinn formed the parish of Our Lord Christ the King Catholic Church in 1926. The first mass was held in the building at 3200 Linwood Avenue (presently Delwood restaurant). In 1934, his rank was elevated to that of monsignor. He spent the majority of his priesthood at Our Lord Christ the King Church, from 1926 until he retired in 1965. In 1966, Quinn was recognized as Citizen of the Year by the Mt. Lookout Community Council; he died later that same year. Quinn was succeeded by Edward Graham, Francis Lammeier, Gerald Haemmerle, Robert Obermeyer, Edward P. Smith, and Adam D. Puntel, the current priest. (Courtesy of Our Lord Christ the King Church.)

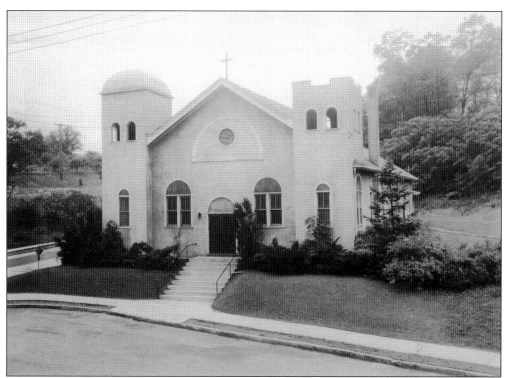

After the first congregation assembled in the Lin-Del building, 3200 Linwood Avenue, plans were quickly implemented to construct a freestanding church (pictured above in 1927 just after completion). Myers Y. Cooper and Edward Crotty sold the land on the corner of Ellison Avenue and Linwood Avenue for the church to be built. The picture below shows the nave, where the congregation sat. The first mass in the church, led by Fr. Edward J. Quinn, was held on March 20, 1927. There were 140 parishioners in attendance. Joseph Hudepohl and Eva Zimmerman were the first couple to be married here on June 29, 1927. In 1956, this building was dismantled, and a larger church—still there today—was erected in the same location. (Both, courtesy of Geo. H. Rohde & Sons Funeral Home.)

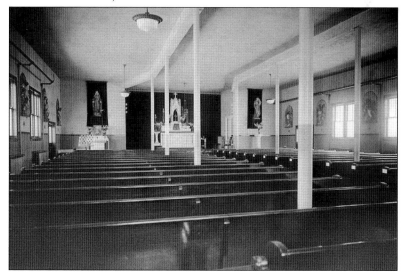

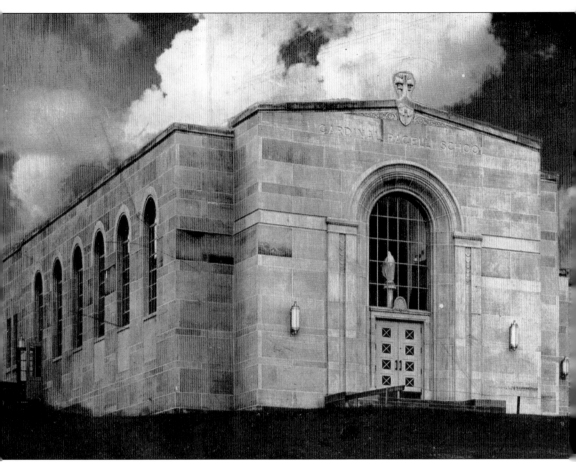

Cardinal Pacelli is a Catholic school for boys and girls from kindergarten through eighth grade. It is situated on a hill along Ellison Avenue next to Our Lord Christ the King Church. Before this grand Romanesque school was built, a small four-room building was constructed on this spot in 1927, shortly after the original church had been completed. Like the church, the school eventually became overcrowded and needed to be replaced in order to accommodate a growing enrollment.

The new building, pictured here, was ready by the first day of school in 1937. Originally called Christ the King School, it was renamed Cardinal Pacelli School. This image was captured in 1937 after construction was completed. By 1963, the school again was in need of additional space. A second floor with eight classrooms was added. (Courtesy of Our Lord Christ the King Church.)

In 1936, Eugenio Cardinal Pacelli visited the United States. At that time, he was papal secretary of state. On October 30, he landed at Lunken Airport as part of his itinerary. He made a special visit to Mt. Lookout to bless the cornerstone of the new school building, which was named in his honor. In 1939, Pacelli was elected Pope Pius XII. (Courtesy of Our Lord Christ the King Church.)

Led by the Sisters of Notre Dame de Namur, the original four-room school opened in 1927 with 108 students. Within 10 years, that number had nearly doubled. This photograph was taken on the first day of school in 1937; students approached the new school from Ellison Avenue after morning mass at the church. The sisters remained at Cardinal Pacelli School until 1971. (Courtesy of Our Lord Christ the King Church.)

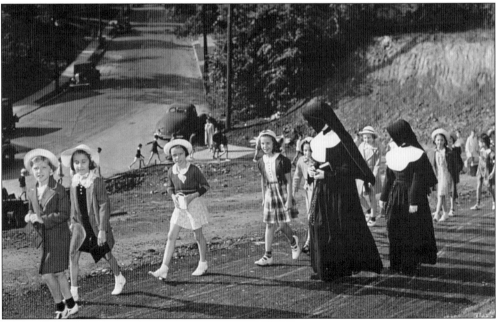

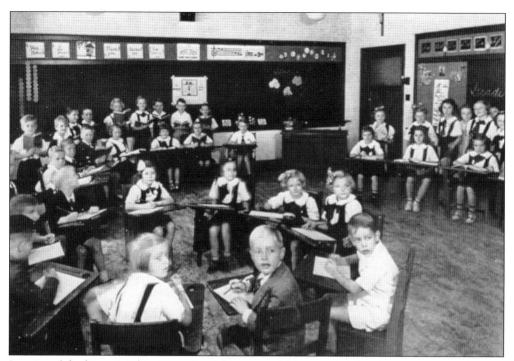

In spite of the historic Ohio River flood that year, which caused delays in construction, the new Cardinal Pacelli School opened on time, September 5, 1937. The picture above, which shows Sister Alice's first- and second-grade class, was taken just after the school year began. Students were split up by grade level in the same room. Marie Schoenle, the only teacher who was not a nun, taught third and fourth grades. Sister Roberta Marie taught grades five and six. Sister Therese, who taught seventh and eighth grades, was also placed in charge of the school. The image below shows the newly constructed school before the second level was added. (Both, courtesy of Our Lord Christ the King Church.)

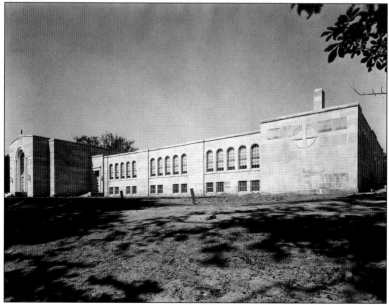

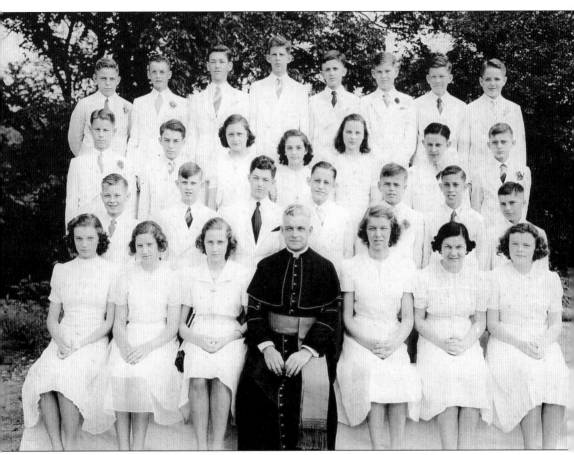

This was the eighth-grade graduating class from Cardinal Pacelli School in 1939. Pictured are, from left to right, (first row) Dorothy Fisher, unidentified, Dorothy Heger, Msgr. Edward J. Quinn, Virginia Guessing, Jane MacNamie, and Jean Hassman; (second row) Bob Schmitt, George Brown, Ward Williams, Jim Sause, Joe Meyer, Bob Brandstetter, and Paul Rutterer; (third row) Walter Hanlon, Billy Meyers, Marian Wolfer, Mary Alice Pharo, Mary Lou Shriner, John Cooper, and Paul Sparks; (fourth row) Joe Homan, Pat Adams, Tom Farrell, Dan Homan, Bob Jones, Dick Young, Bob Manley, and Andrew Gilligan. In the Christ the King 75th-anniversary publication, Paul Rutterer recalled the original four-room school building, which he attended during his early grades: "There were four large classrooms. There were two small rooms between the large rooms. They served as music rooms, a library, first aid, an eye exam room, and a punishment room. There was a full basement. It served as a cafeteria, auditorium, and basketball court." (Courtesy of Sharon Stanton.)

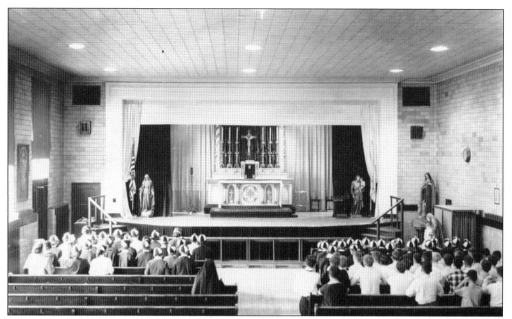

The church's first structure lasted for nearly 30 years. In 1956, work began on a new church that currently towers above Mt. Lookout Square. During construction, parishioners attended mass in the school gymnasium at Cardinal Pacelli. There was already a stage there, which served as a pulpit for Monsignor Quinn. The pews were moved from the old church into the gymnasium. (Courtesy of Our Lord Christ the King Church.)

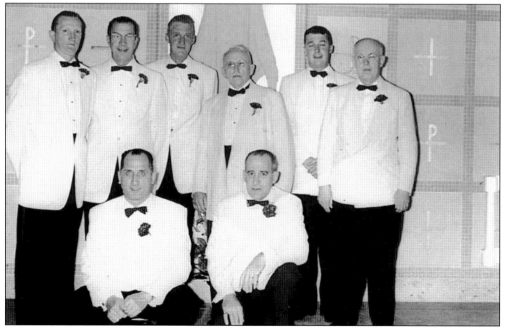

In this photograph, ushers get ready for the very first mass in the new church in 1957. Standing from left to right are Harry Heskamp, Larry Knollman, A. Rohan Kelley, George McDonald, Kevin Kelley, and Dr. Charles Simon. Dennis Harrington (left) and Ben Hein are in the front row. (Courtesy of Our Lord Christ the King Church.)

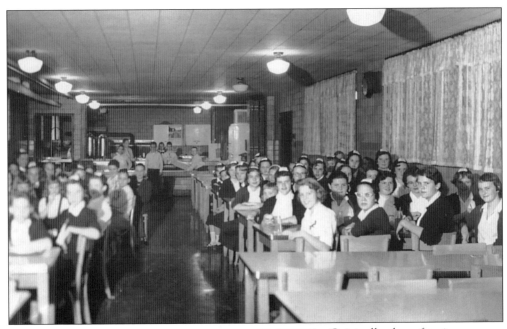

Originally, the cafeteria was on the basement level of Cardinal Pacelli School. Mrs. Schoettmer and Mrs. Wilcox prepared the lunches. Today, this space is used for preschool and kindergarten classes. After the school was remodeled and the second level was added, the new cafeteria was moved to the second floor. (Courtesy of Our Lord Christ the King Church.)

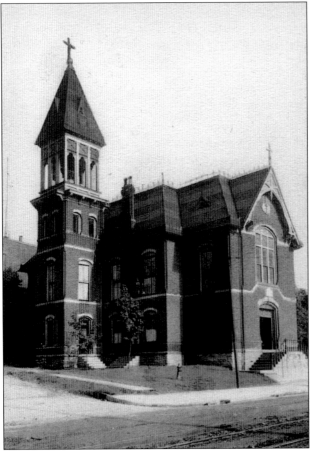

Although located just inside the Linwood border, some Mt. Lookout residents attended church at Our Lady of Loretto on the corner of Eastern Avenue and Heekin Avenue. It was originally constructed as the Linwood Town Hall in the late 1800s. The *Mt. Lookout Observer* promoted summer festivals at this church each year. Today, it is Ark by the River Church. (Courtesy of the Cincinnati & Hamilton County Public Library.)

LeBlond Avenue (originally called Beechwood Avenue) was named after R.K. LeBlond (1864–1953). In the c. 1900 image above, he is sitting front and center. LeBlond founded the R.K. LeBlond Machine Tool Company. When he died, LeBlond stipulated in his will that his 40-room house and property (below), located at 3660 Vineyard Place, was to be gifted to the Archdiocese of Cincinnati. In 1960, it was purchased by the Ursuline Sisters of St. Ursula Convent and Academy to create a new grade school called St. Ursula Villa. The first principal was Sr. Mary Lawrence Hartmann. The original house remains part of the school grounds. (Above, courtesy of Sharon LeBlond and Marilyn Laker; below, courtesy of the General Photographic Collection–Suburbs [SC#59], Cincinnati Museum Center.)

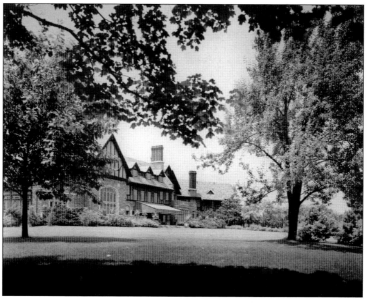

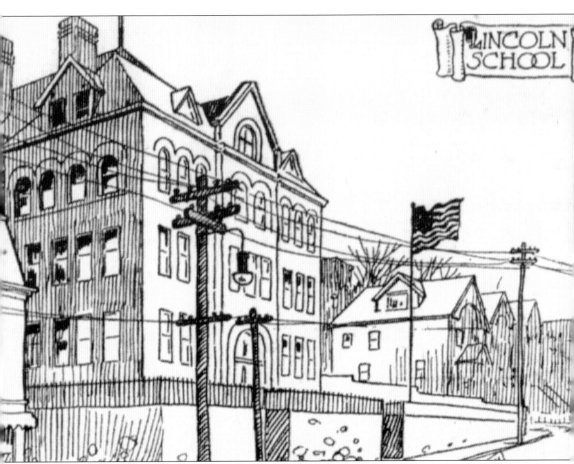

The Lincoln Public School was built in 1898. It is located on the corner of Delta and Golden Avenues. Although most Mt. Lookout children attended Kilgour Elementary after it was built in 1922, some attended the Lincoln School depending on where their house was located. In the early years of American education, this school had one floor set up to mimic an apartment. Female students were tasked with taking care of the "apartment" and weaving rugs for the floors, while the boys refined their woodworking skills. Although still standing, this building is no longer used as a school. In 1986, the interior was remodeled and repurposed for office space. For a brief time, a restaurant called Funky's Blackstone Grille opened in this space. (Courtesy of the *Cincinnati Post* Collection, Cincinnati Museum Center.)

Nine
CELEBRATIONS AND COMMUNITY

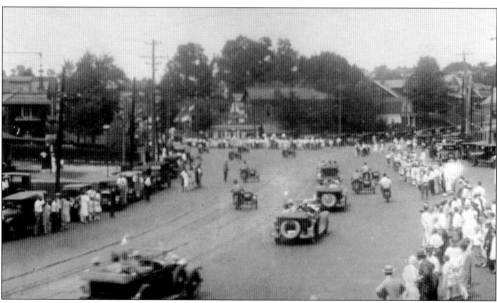

August 6, 1927, was a day of celebration. After landing at Lunken Airport, Charles Lindbergh was escorted in a motorcade to Redland Field, where he gave a speech. Throngs of people gathered in Mt. Lookout Square to catch a glimpse of the celebrity as he rode by. It was reported that many people were emotional, and some stood with their hands over their hearts. (Courtesy of Sharon Stanton.)

The *Spirit of St. Louis* did not have a front windshield, because the fuel tanks were stored in the front cabin. The only visibility Charles Lindbergh had was through a periscope or looking out the side windows. Lindbergh's record-breaking solo flight from New York to Paris in May 1927 made him an overnight star both in the United States and across Europe. For his accomplishment, Lindbergh claimed the Orteig Prize of $25,000, which is worth approximately $420,000 in 2024. Just a few months later, Lindbergh visited Cincinnati. The *Spirit of St. Louis* touched down at Lunken Airport on August 6, 1927, at 1:58 p.m. Men were stationed to guard the plane at the airport while Lindbergh's motorcade made its way to Redland Field. Lindbergh was 25 years old in this photograph. (Courtesy of Cincinnati Aviation Heritage Society.)

This picture was taken in 1941, just after the Mt. Lookout Theater had been completed. Aluminum was an extremely valuable resource during World War II. The Mt. Lookout Civics Club (now known as the Mt. Lookout Community Council) encouraged residents to donate aluminum products to support the war effort. (Courtesy of the Mt. Lookout Community Council.)

Dr. William "Bill" Black is pictured here in 1965 with his children, (from left to right) Stephanie, Preston, and Allison. The family resided at 3303 Mannington Avenue. Black's dentist office was located at 1056 Delta Avenue. Just like her father, Stephanie became president of the Mt. Lookout Community Council, and she was recognized as Citizen of the Year. (Courtesy of Stephanie Black Hughes.)

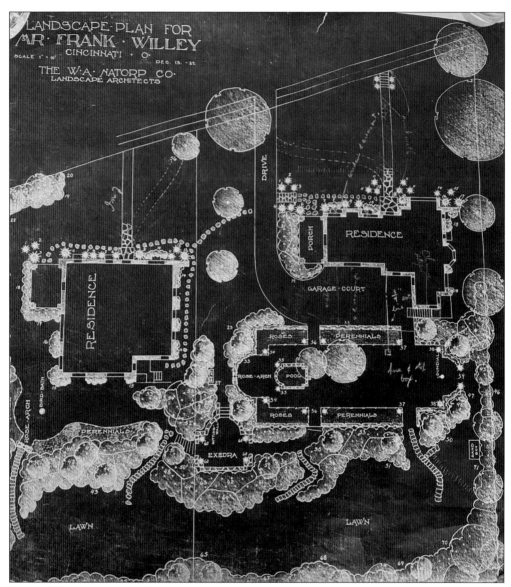

Frank Willey, who lived at 3330 Observatory Avenue (right), built 3338 Observatory Avenue at the intersection of Herschel Avenue for his mother-in-law, Rosa Rendigs. These Natorp blueprints, dated December 13, 1927, show that the two homes had access to one another's backyards. Willey was president of the Willey-Wray Electric Company, which was established in 1915. He was praised for being one of the first businessmen in Cincinnati to offer profit-sharing opportunities for his employees. He was also a Cincinnati Board of Education member from 1936 to 1944. In the 1970s, Nick and Donna Mancini purchased the home at 3338 Observatory Avenue. Nick sought ways to improve Mt. Lookout; he was actively involved in beautifying the two concrete traffic islands on Herschel Avenue: one at Hardisty Avenue and the other at Observatory Avenue. He and other residents, such as Tom Arnold and Bob Owens, planted trees, flowers, and bushes on the islands. (Courtesy of the author.)

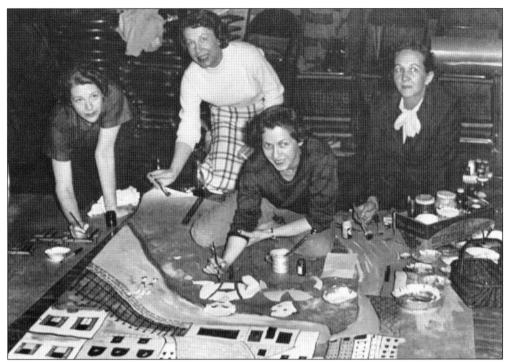

"Hits and Mrs." was an annual fundraiser that was begun in 1950 by the PTA at Cardinal Pacelli School. Each year, parents and teachers collaborated to create fun skits, including singing and choreographed dance numbers, for an adults-only audience. Costumes and sets were made by volunteers (above). Soon, the fundraiser was so popular that it raised $5,000 annually; each fall, the three-night event was sold out. Below, from left to right, John Rees LaBar, Vickey Blakeney, Dan Herzog, and Tom Geoppinger rehearse for an upcoming show. Jim Krumme of 704 Tweed Avenue was the writer and director for many of the productions during the 1960s. He later became president of the Ault Park Advisory Council. "Hits and Mrs." came to an end in 1989. (Above, courtesy of Our Lord Christ the King Church; below, courtesy of Jewel Geoppinger.)

On December 6, 1956, Gay Maerker (left), of 3227 Glengyle Avenue, and Mrs. Frank Johnson, of 3224 Glengyle Avenue, took their children to a picnic at Ault Park. According to records, the temperature reached 70.9 degrees, making it the warmest December day in over 80 years. (Courtesy of Cincinnati Parks Library and Archives.)

Two residents on Lindell Avenue filed an injunction to prevent the Mt. Lookout Swim Club from being built. The two women argued that the building of the pool was unconstitutional. On April 26, 1960, Judge Charles S. Bell ruled in favor of the swim club, and construction proceeded. The architects were Steinkamp & Nordloh. This is a member's handbook from 1964. (Courtesy of Barb Obermeyer Johnson.)

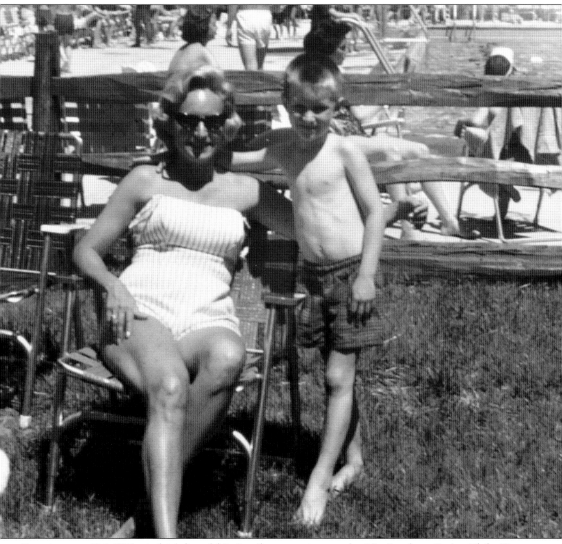

Growing up, T. Jeff Davis (right) and his family spent time at the Mt. Lookout Swim Club. He is pictured here in 1961 with his mother, Marjean Wenstrup Davis. She had a successful career in Mt. Lookout as a realtor. The Davis family lived on Paxton Avenue when the Faxon Hills subdivision was being developed in the 1950s and 1960s. When Susanna Walsh Hinkle died, her heirs sold her 150-acre estate, called Belcamp, to the Faxon Realty Company. The property bordered Grandin Road, Linwood Avenue, Paxton Avenue, and Delta Avenue. The house itself was built in 1900 by Nicholas Walsh Sr., but the land also included a swimming pool, garage, barn, horse stables, and even a distillery. Some local residents were sad to see the land cleared and developed, as it was described as a communal "playground" for kids to enjoy nature and camping. (Courtesy of T. Jeff Davis.)

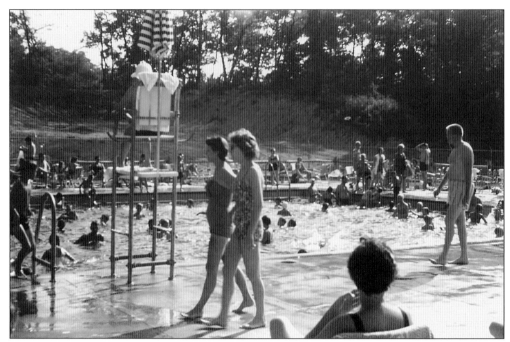

The Mt. Lookout Swim and Tennis Club offered entertainment for kids and an opportunity for socializing for parents. Before a filtration system was put in, lifeguards had to pour chlorine into the pool by hand while kids sat around the edges, kicking their legs to mix up the chemicals in the water. (Courtesy of T. Jeff Davis.)

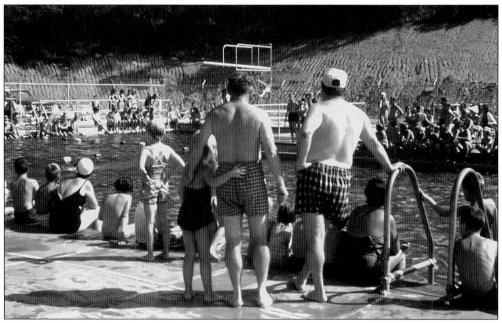

Today, the Mt. Lookout Swim and Tennis Club looks very different than it did in 1960, shortly after it opened. Located at Totten Avenue and Ellison Avenue, the club has had a thriving membership for over half a century. Prior to being built, this land was mostly woods and a ravine. (Courtesy of T. Jeff Davis.)

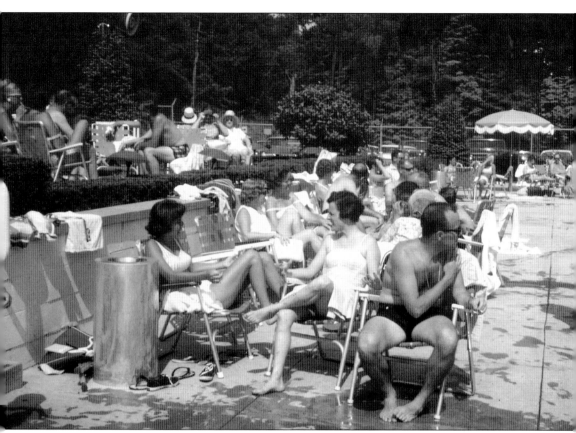

In the forefront, something has caught the attention of Jack Wenstrup (right) in 1961. Next to him is his wife, Joan Carletti Wenstrup. Wenstrup was one of the founders of the Mt. Lookout Swim Club, and he was involved in many "Hits and Mrs." productions at Cardinal Pacelli School. A local optician who practiced for nearly 70 years, Wenstrup passed away in 2019. Wearing sunglasses in the background is Dr. William "Bill" Black, a dentist whose office was located near Mt. Lookout Square at 1056 Delta Avenue. In 1978, Black provided testimony regarding dental records in the trial of Larry Ralston, who was found guilty of murdering a 16-year-old girl in Clermont County. Black served as president of the Mt. Lookout Community Council, and in 1984, he was recognized for his contributions to the community by being named Citizen of the Year. Black also died in 2019. (Courtesy of T. Jeff Davis.)

Elwood Jones (center) is at the Mt. Lookout Swim Club with his son Jeffrey (left) and his daughter Lynda in 1961. Behind him is the kids' friend Cliff Robson. The Jones family resided at 2918 Van Dyke Drive, which would have been an easy walk to the swim club. The Jones Insurance Agency, at 3215 Linwood Avenue, was owned by Elwood and his brother Walter Jones. (Courtesy of T. Jeff Davis.)

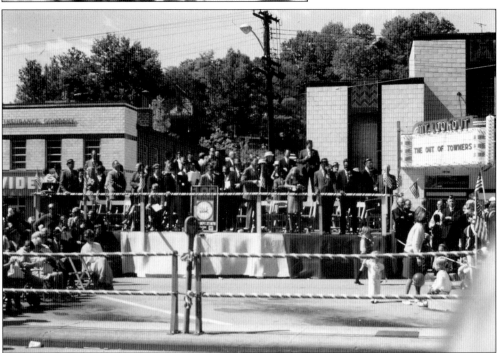

On September 27, 1970, the centennial celebration of Mt. Lookout was held, appropriately enough, in Mt. Lookout Square. A parade began in the morning on Tweed Avenue, ending in the square, where carnival booths and art shows were set up. Dianne Dreyer, 19 years old, was voted "Queen of Mt. Lookout." Square dancing and performances by Mark Mauer and the Straight Blues entertained the crowds. (Courtesy of T. Jeff Davis.)

Walter A. "Walt" Hanlon was a Cincinnati police officer and later a sergeant in District 2. According to his obituary in 1984, he was the first officer to work on a regular basis with a police dog. Hanlon grew up at 3222 Nash Avenue and graduated from Cardinal Pacelli in 1939. (Courtesy of T. Jeff Davis.)

Pictured here from left to right are Victor de Lorenzo, Dr. Jerome "Jerry" Janson, Bernard "Ben" Hein, and T. Shelby Howard. De Lorenzo owned Mt. Lookout Television at 3204 Linwood Avenue for 43 years. Hein owned Hein's Pharmacy at 3200 Linwood Avenue for more than 35 years. Both spaces are used by Delwood today. (Courtesy of T. Jeff Davis.)

Jack O'Conner smiles as he drives through the square during Mt. Lookout's centennial celebration in 1970. Jack has been described as "quite the character" and a "man about town." In the background, the Mt. Lookout Theater is showing *The Out of Towners*. Rohde Funeral Home can be seen to the right. (Courtesy of T. Jeff Davis.)

Joseph and Helen "Kandy" McGoff celebrated Mt. Lookout's 100th anniversary with some RC Cola. They lived at 3833 Earls Court View from 1958 to 1976. Parishioners of Our Lord Christ the King Church, the McGoffs regularly volunteered to help with Cardinal Pacelli's "Hits & Mrs." talent show for 30 years. The McGoffs were known for hosting a party after the show's final performance. (Courtesy of T. Jeff Davis.)

Harry C. Heskamp, who has been immortalized by his nickname "Mayor of Mt. Lookout," was awarded Citizen of the Year in 1972 by the Mt. Lookout Community Council. Here Bill Rohde (left) presents Heskamp with the plaque that reads, "In recognition of outstanding leadership and service to our community this award is proudly given to Harry Heskamp." A World War II veteran, Heskamp ran the Heskamp Printing Company (started by his father); he was also the editor and publisher of the *Mt. Lookout Observer* for 30 years. He attended over 70 Reds Opening Days, and in 1985, he was presented with a Key to the City of Cincinnati. Heskamp and his wife, Betty, raised five boys in their home at 3278 Nash Avenue, which they purchased in 1952; the home remains in the family today. In 1994, Bill Rohde was also recognized as Mt. Lookout's Citizen of the Year. Like Heskamp, Rohde served in the military, and he founded the Basco Company, which manufactures shower doors. (Courtesy of Tom Heskamp.)

**OPEN HOUSE SUNDAY
JULY 27, 2-4 P.M.**

Executive family home at 3939 Devonshire Drive, in the heart of Mt. Lookout. First floor family room with wooded rear view, den, breakfast room, living room with walnut parquet floor, WBFP and gas starter, dining room, powder room, entry. Upstairs four bedrooms, two baths, one newly remodeled. Basement playroom with WBFP and bar. Well-insulated, storm windows, air conditioned, electro-static air filter, two car garage. $178,500 - Owner.

871-2647

Because Mt. Lookout is such a desirable place to live, property values have soared over the last two decades. In December 2023, the median sale price for a home in this neighborhood was $665,000. This *Mt. Lookout Observer* advertisement from 1986 listed 3939 Devonshire Drive for $178,500. More recently, the house sold for $672,000 in 2017. (Courtesy of the Mt. Lookout Community Council.)

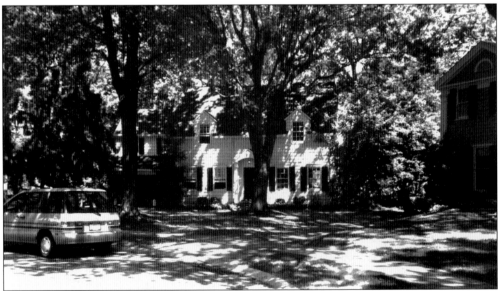

The property at 1330 Hayward Court was selected for the home of characters Tom and Frank, played by Ed Harris and Michael Patrick Carter, respectively, in the 1994 film *Milk Money*. This lovely yellow home is situated on a cul-de-sac of a street that is quintessentially Mt. Lookout. For two weeks prior to filming, landscaping professionals watered and manicured the grounds. (Courtesy of Kilgour Elementary.)

Above, scenes from *Milk Money* were filmed in front of Bracke's Meats and Produce in 1993. Filming made headlines in Cincinnati, as Paramount Pictures reportedly injected about $5 million into the local economy. Below, Tom and Jewel Geoppinger were the editors and publishers of the *Mt. Lookout Observer* for about 10 years. They took over in 1985 following Harry Heskamp's retirement after 30 years. That same year, the Mt. Lookout Community Council announced that Tom was Citizen of the Year. In 1996, Jewel Geoppinger became the first woman to receive the same award. (Above, courtesy of Kim Kolthoff Rice; below, courtesy of Jewel Geoppinger.)

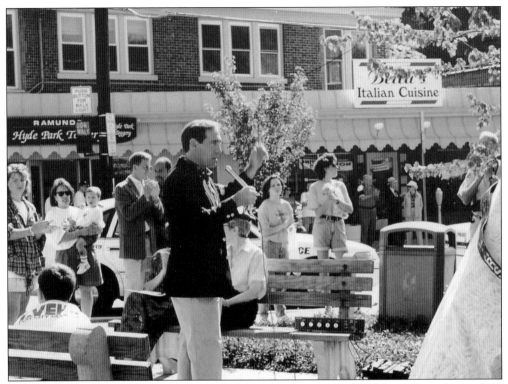

Steve Rohde agreed to organize Mt. Lookout's 125th-anniversary celebration, which was held on September 29, 1995. Rohde (pictured above) gave a speech to the crowd in the square as part of the festivities. At the time of this picture, Ramundo Custom Tailor had just relocated from Hyde Park to Mt. Lookout. Betta's Italian Cuisine was then a new restaurant and was receiving accolades for its menu selections. Inspired by the film *Field of Dreams*, below is one of the many creative floats that participated in the parade for the anniversary. The homes in the background were razed in the early 2000s to build several new townhomes. Millions Café, with its original sign, has been a landmark of sorts since 1945. (Both, courtesy of Kim Kolthoff Rice.)

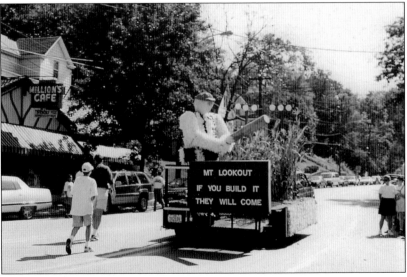

In the months leading up to the quasquicentennial event, residents from a number of streets collaborated and competed to build floats for the parade. In the above image, from left to right, Michael Zultoski, Bud Uhl (of 3214 Lookout Drive), and Sharon Stanton (of 3218 Lookout Drive) stand next to the frame of their street's float. It was built in Uhl's driveway. Zultoski was the driver of the float. Stanton still lives in her home; she has been a resident of Lookout Drive since 1976. Below, Amy Uhl (far left) and her sister Beth Uhl Green (far right), who grew up on Lookout Drive, walk to Mt. Lookout Square with their banner. Their street has the unique advantage of having quick access to the square via a shortcut staircase. (Both, courtesy of Amy Uhl.)

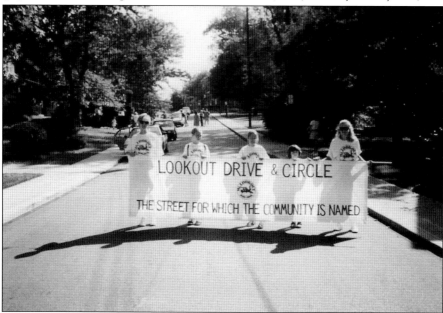

119

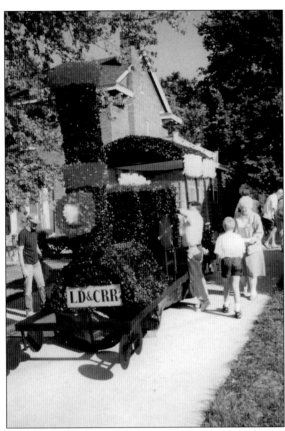

Carefully crafted on the driveway of Bud and Pat Uhl's home, 3214 Lookout Drive, this was the winning float in the parade competition commemorating Mt. Lookout's 125th birthday. Residents from Lookout Drive and Lookout Circle worked together to create their float in the form of a locomotive. (Courtesy of Amy Uhl.)

As the sign indicates, John Resetarits was the recipient of Mt. Lookout's Citizen of the Year award in 1993. In this image, he is riding in the back next to his son Jim. His wife, Christianne "Chris," and daughter Josie are waving. The driver is unidentified. (Courtesy of Amy Uhl.)

Lookout Drive and Lookout Circle have hosted a Fourth of July street parade for six decades. It began in 1960 when kids marched down the street, banging pots and pans, until they reached the home of Frank Hollenkamp, 3301 Lookout Drive. It was the kids' way of paying tribute to Hollenkamp, a World War II veteran. From then on, Bud and Pat Uhl, of 3214 Lookout Drive, organized the annual celebration. Their house was where people gathered to begin the parade; the Uhls also hosted a party when the parade was over. This photograph was taken on July 4, 1998. The scene captures the spirit and energy of the neighborhood. Uhl (center) always wore his "Uncle Al" hat, as his daughter Amy Uhl describes it. To the left, wearing a green beret, is Paul Lindsay Jr., a longtime friend and neighbor of the Uhls. (Courtesy of Amy Uhl.)

Rain or shine, the Fourth of July parade always started at noon at the home of Bud and Pat Uhl, which is the first house on the left in this photograph. This was the Uhls' residence for nearly 50 years. Nine children, all of whom attended Cardinal Pacelli School, grew up in this house. Some of their most vivid memories of the Independence Day parades include a large wash bin full of ice-cold Coke bottles, a water balloon contest for kids and another for adults, a bike-decorating contest, and a bicycle race up and down Lookout Drive and Lookout Circle. This image was taken just east of Van Dyke Drive looking east toward Herschel Avenue. In the lower-left corner, one of the Uhls' granddaughters gets ready for the parade on July 4, 1998. Streamers were hung from the Uhls' house across the street to mark the starting point. (Courtesy of Amy Uhl.)

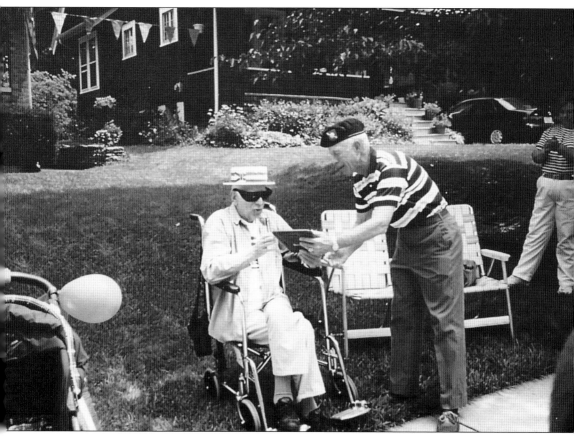

On July 4, 2000, Paul Lindsay Jr. presented a plaque to Bud Uhl as a thank-you from the community for 40 years of Independence Day parades and festivities on Lookout Drive and Lookout Circle. The celebration began each year with Uhl leading the Pledge of Allegiance, followed by the crowd of neighbors singing traditional songs like "The Star-Spangled Banner" and "God Bless America." Lindsay was a retired lieutenant colonel of the US Army Special Forces. He was also a board member of the Mt. Lookout Community Council. Lindsay and his wife, Nancy, raised their six children at 3200 Lookout Circle. This picture was taken during Uhl's last parade; he died later that year in November 2000. Lindsay passed away in 2017. In spite of these losses, Lookout Drive and Lookout Circle continue to hold a Fourth of July parade each year. (Courtesy of Amy Uhl.)

The Olberding family organized the Reggae Run in honor of Maria Olberding, who was passionate about running and reggae music. Olberding, who lived on Shattuc Avenue, was stabbed to death while running through East Hyde Park on the evening of May 22, 1994. She was training for the Boston Marathon. The Olberding family turned their tragic loss into a community tradition that raised money for the Council of Child Abuse of Southwestern Ohio, Starfire, and the Make-a-Wish Foundation. The first Reggae Run was held on October 7, 1994, at Ault Park. Approximately 2,000 runners participated in the inaugural 5K race. Beginning at the pavilion, the route continued west on Principio Avenue to Herschel Avenue, west on Hardisty Avenue, north on Delta Avenue, and east on Observatory Avenue back to the park. From left to right, Margie Ackmann Cunningham, Judd Jacobs, and Shelley Smith pose in front of the 10th Reggae Run banner in 2003. (Courtesy of the author.)

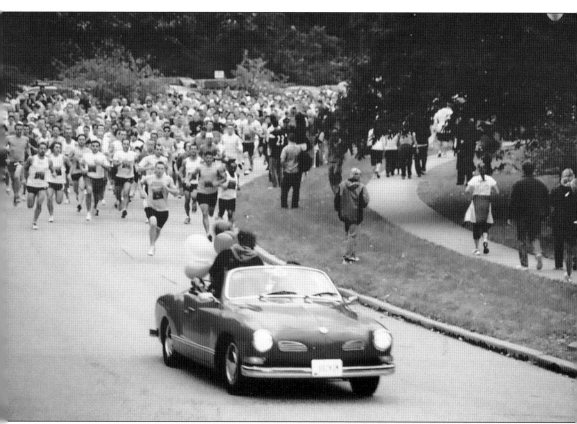

At the time of her death, Maria Olberding drove a 1973 Volkswagen Karmann Ghia. She had owned it for about a year. To celebrate the 10th anniversary of the Reggae Run, Patti Olberding, Maria's younger sister, drove the car ahead of the runners. This became a tradition each year thereafter. The success and popularity of the Reggae Run grew quickly. By 2003, the number of race entrants reached 7,000. Every year, Maria's father, Don Olberding, made 100 gallons of chili for the event. The Ark Band performed Maria's favorite reggae music each year except for one. Due to the growing crowd size, the final Reggae Run at Ault Park took place in 2012. It moved to Eden Park for one year, but the family then decided to stop the event. This image was captured at the beginning of the 2009 Reggae Run. (Courtesy of Patti Olberding.)

Mt. Lookout's annual Luminaria tradition was the brainchild of Elmer Scherman, although he had discovered the Spanish custom by reading about it. In 1976, the Mt. Lookout Community Council needed to raise funds to build a float for the nation's Bicentennial celebration. In the first year, 900 Luminaria kits were sold for $3.75 each. Scherman was given the honor of Citizen of the Year in 1978. An avid gardener, he helped design and create flower boxes and floral arrangements for Mt. Lookout Square and Ault Park. Nearly 50 years after it was introduced, Luminaria continues as a holiday tradition every December. Clusters of families and friends can be seen each year walking up and down streets to see not only the Luminaria bags but holiday lights and decorations as well. This picture was taken during Luminaria on December 10, 2023, at 3456 Arnold Street. (Courtesy of the author.)

John "Don" Rohde (1927–2008) and his wife, Gerry Murphy Rohde, were photographed at an event in Mt. Lookout Square in about 2000. Don's grandfather established Geo. H. Rohde & Sons Funeral Home in 1910. He joined the family business from 1948 until 2002, at which time their son Steve took over as director of the funeral home. (Courtesy of Geo. H. Rohde & Sons Funeral Home.)

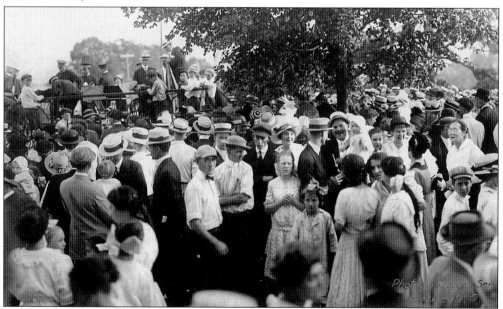

In 2020, Mt. Lookout quietly turned 150 years old. Due to the pandemic, a typical celebration was not possible. Under normal circumstances, a commemorative event would most certainly have been promoted. Much has changed in the time since this group gathered at Ault Park in 1915, but the sense of community remains the same. (Courtesy of Cincinnati Parks Library and Archives.)

DISCOVER THOUSANDS OF LOCAL HISTORY BOOKS FEATURING MILLIONS OF VINTAGE IMAGES

Arcadia Publishing, the leading local history publisher in the United States, is committed to making history accessible and meaningful through publishing books that celebrate and preserve the heritage of America's people and places.

Find more books like this at
www.arcadiapublishing.com

Search for your hometown history, your old stomping grounds, and even your favorite sports team.

Consistent with our mission to preserve history on a local level, this book was printed in South Carolina on American-made paper and manufactured entirely in the United States. Products carrying the accredited Forest Stewardship Council (FSC) label are printed on 100 percent FSC-certified paper.